IMAGES
of Rail

SACRAMENTO
NORTHERN RAILWAY

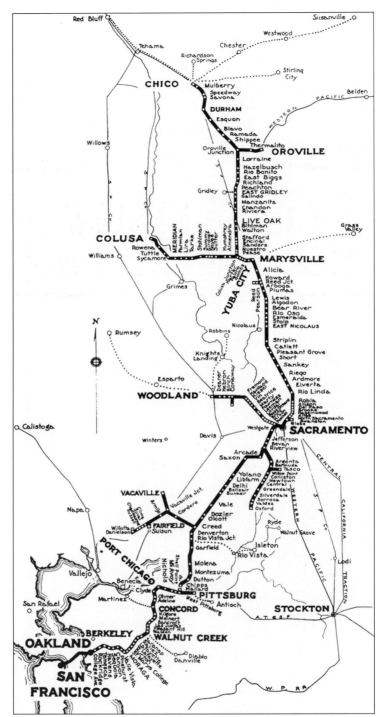

This map shows the Sacramento Northern Railway in 1939 at its greatest extent, from Chico to San Francisco, together with the branch lines (save for the Walwood Branch going east from Meinert and the Dixon Branch north from Dozier).

IMAGES
of Rail

SACRAMENTO
NORTHERN RAILWAY

Paul C. Trimble

Published by Arcadia Publishing
Charleston SC, Chicago IL, Portsmouth NH, San Francisco CA

Printed in Great Britain

Library of Congress Catalog Card Number: 2005928799

For all general information contact Arcadia Publishing at:
Telephone 843-853-2070
Fax 843-853-0044
E-mail sales@arcadiapublishing.com
For customer service and orders:
Toll-Free 1-888-313-2665

Visit us on the internet at http://www.arcadiapublishing.com

*To the memories of my mother, Frances Castelhun Trimble, who rode the Sacramento
Northern and who never discouraged my affection for railways; of my grandmother, Minnie
Elizabeth Castelhun, who took my mother to ride on the Sacramento Northern;
and my great grandmother, Minnie Case, who waited for my mother at
the Sacramento Northern depot in Chico.*

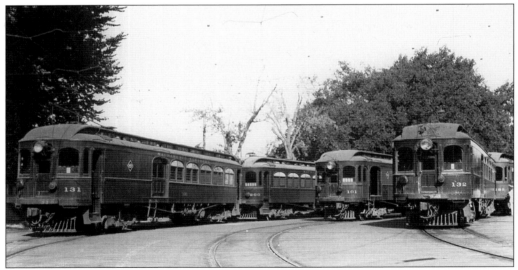

When built in 1925, the four-track loop in back of Sacramento's Union Station was home to the
Sacramento Northern Railroad (nee Northern Electric), San Francisco-Sacramento Railroad (nee
Oakland, Antioch, & Eastern), and the Central California Traction Company. By 1939 when this
photograph was made, the Traction Company's interurban lines were six years into the history
books and the other two roads had merged to become the Sacramento Northern Railway.

CONTENTS

ACKNOWLEDGMENTS

Thanks go to those many rail photographers who photographed the Sacramento Northern, particularly in times when money for film was scarce. Thanks also go to Steve Graves and John T. Poultney, my editor at Arcadia Publishing, who encouraged me to do this book. And special thanks to my daughter, Debbie Trimble, for adapting my typescripts to modern technology. All materials in this book are from the author's collection.

INTRODUCTION

In the post–World War I years, Mrs. Bess Castelhun of San Francisco and her daughter, Frances, rode the No. 4 streetcar line to the city's Ferry Building, where they got off and boarded a Key Route ferry for Oakland. At the Key Pier, Mrs. Castelhun saw her little girl board a Sacramento Northern interurban train, paying parlor car fare so that Frances wouldn't have to change cars at Sacramento. Six hours or so later, Frances got off the train at Chico, where her grandmother, Minnie Case, was waiting for her granddaughter to spend the summer with her. Frances retained this memory of riding the Sacramento Northern into adulthood, and as my mother, she passed it on to me. Perhaps this ignited my initial interest in the Sacramento Northern interurbans, which were abandoned well before I was able to acquire my own memories of them.

Sadly, there is a declining number of Americans who recall those halcyon times when parents deemed it safe and normal to place a child in the good care of friendly and efficient interurban crews, including those of the Sacramento Northern Railway.

The Sacramento Northern, or SN, was formed in 1928 by merging what had once been the Northern Electric and the Oakland, Antioch, & Eastern Railways, running between Chico and Sacramento, and Sacramento and Oakland, respectively. Six months shy of Pearl Harbor, the last SN interurban services ended and the railroad became freight only.

The interurban (Latin for "between cities") electric railway was unique to North America, running between cities and towns on private rights-of-way and then in city streets a la streetcars to stations and terminals.

The interurban brought sweeping changes to rural America in the forms of industrial employment and quicker transport of perishables to market. Low fares allowed farm children to attend high school. Farmers developed closer commercial ties, bringing them a better return for their labors. The farmwife was liberated from the mail order catalog since she could now shop locally, thus boosting small-town economics. With their new prosperity, however, people bought automobiles, not train tickets, and taxed themselves for paved roads and highways. The interurban railway was a victim of its own success.

The interurbans' best years were just prior to the automobile age, the peak year nationally being 1917 with 15,562 miles in operation. In 1918, only 52 miles of track were built, offset by 144 miles of abandonments. The electric railway industry began a painful decline, and 1926 was its last profitable year. A decade later, only 5,411 interurban miles remained to yield a mere 0.6 percent rate of return to the shareholders and no new rolling stock being built.

By 1993, what was once part of the SN main line in Solano County had become a customerless, very minor branch of the Union Pacific Railroad, and was sold to the Bay Area Electric Railroad Association whose Western Railway Museum is adjacent to the SN. Today about four miles of those rails have had the electrification restored and thousands of visitors annually ride vintage interurbans over the SN. While just a museum operation, it is noteworthy that those 22.3 miles of the SN have never been officially abandoned. Moreover, Sacramento RT Metro, BART, and Sacramento River Train ride over parts of the SN right-of-way. The Sacramento Northern lives!

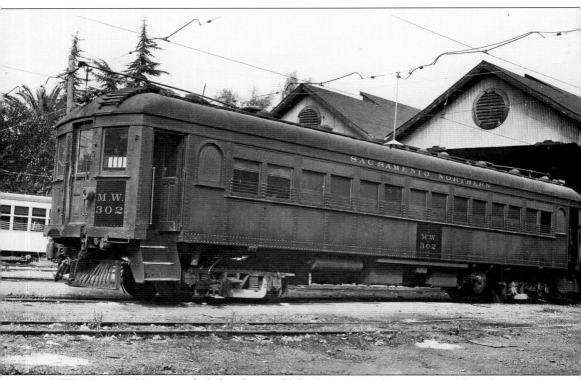

MW 302, ex-1020, certainly led a charmed life, for in 1962 the car was sold to the Bay Area Electric Railroad Association, or BAERA. At the BAERA's Western Railway Museum, the car was restored as OA&E trailer No. 1020 and is now used on special runs. This 1940s photograph shows MW 302 at Mulberry Carhouse in Chico.

One

THE NORTH END

What would later be called the North End of the Sacramento Northern Railway was incorporated on June 14, 1905, as the Northern Electric Railway. This interurban ran from Chico to Sacramento via Yuba City and Marysville with branch lines from Chico to Hamilton, Tres Vias to Oroville, and Marysville to Colusa, as well as from Sacramento to Woodland and Swanston. The Northern Electric, or NE, also ran streetcar lines in Chico, Sacramento, and Marysville–Yuba City.

While construction of the NE began in 1905, the twin geneses of the electric railroad were a pair of horsecar lines in Chico and in Marysville, running to Yuba City. The franchises were absorbed by the NE and rebuilt to interurban standards. The inaugural run was from Chico to Oroville on April 25, 1906, and on September 7, 1907, the trains were running to Sacramento.

The Northern Electric was reorganized as the Sacramento Northern Railroad on June 20, 1918, and merged with the South End on December 31, 1928, thereafter to be known as the Sacramento Northern Railway.

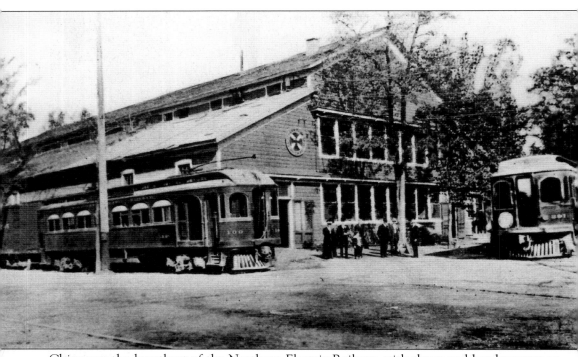

Chico was the heartbeat of the Northern Electric Railway, with shops and headquarters at Mulberry on the edge of town. Here NE No. 100, which made the NE's first revenue trip in 1906 from Chico to Oroville, and trailer 201 pose on what is probably the inaugural day.

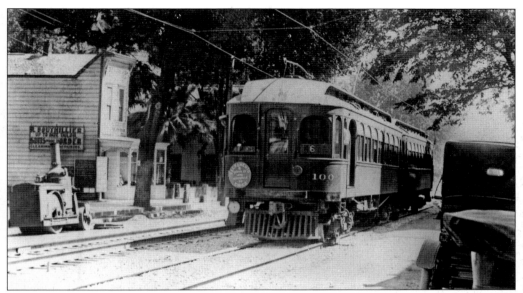

This 1907 photograph shows one of the earliest runs of a NE train in Chico, in from Oroville. Note that the street is not yet paved and the train is running on the opposite track. (Courtesy the late Stephen D. Maguire, author's collection.)

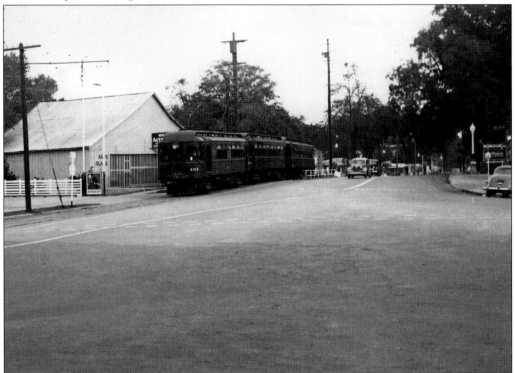

In 1940, a trio of handsome Niles-built cars headed by passenger-baggage combo No. 101, followed by motor No. 200 and parlor car *Bidwell*, arrives at Chico, the "Almond Capital of the World." (Courtesy the late Stephen D. Maguire, author's collection.)

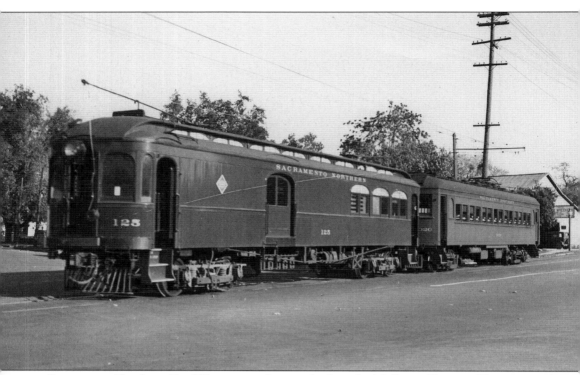

Sacramento Northern No. 125 was one of six cars built in the Mulberry Shops in Chico to match those from the Niles Car Company in Ohio. That the NE saw itself a freight as well as a passenger carrier is evident since the baggage-express section has been lengthened to where only a few seats remain. The No. 1020, as a motor, is a South End car working the North End.

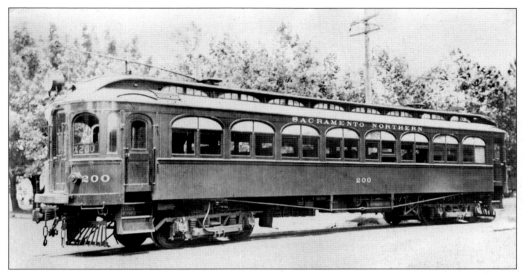

The Northern Electric Railway only ordered three passenger motors from Niles and only No. 200 of the trio survived in its original configuration until the end of passenger service, although it had to be rebuilt twice following collisions.

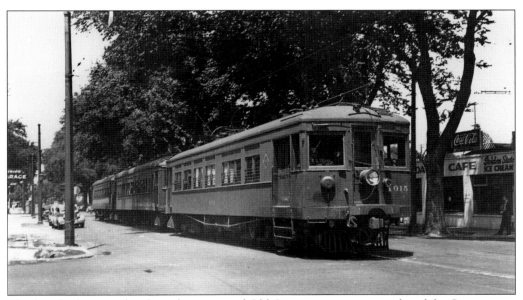

The big shade trees that line the streets of Old Sacramento were a godsend for Sacramento passengers in the hot days of summer. For the big green interurbans, this would be their last relief before venturing into the open countryside en route to Chico. The picture was made in 1939.

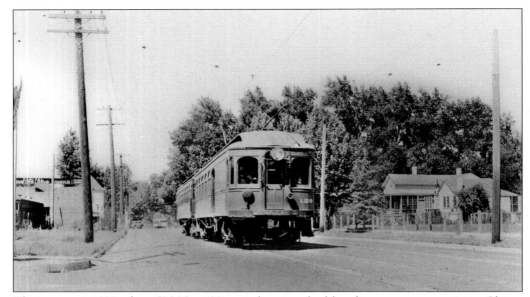

The year was 1939 when SN No. 129 was photographed heading a two-car train in Chico. The train indicator reads Train 2, meaning it is from Sacramento and the time is about 2:00 p.m. In the background is a Sacramento Northern streetcar. (Bert H. Ward photograph, author's collection.)

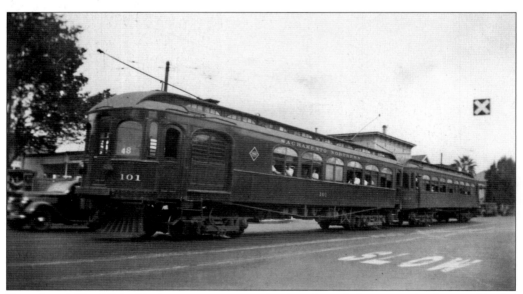

Even though No. 101 had its baggage-express section lengthened, the car retained its good looks. No. 101 headed a railfan special consisting of 101, 200, and the *Bidwell* on the last Sunday before abandonment, and made the final Sacramento–Chico run on October 30, 1940.

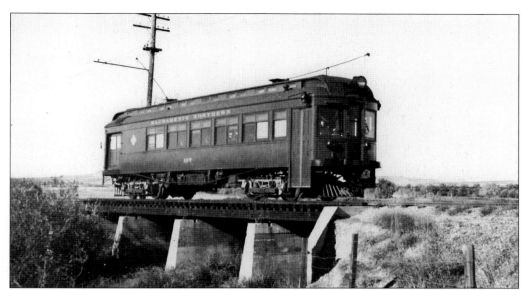

Originally a trailer, No. 107 was rebuilt into a motorized combo in 1912. In 1931, lacking patronage on the Oroville Branch during the Great Depression, it was rebuilt into a single-end, one-man car, with air-operated doors on the new front end. In 1938, passenger service to Oroville ended and No. 107 reverted to a two-man car. This 1937 view is on the Oroville Branch.

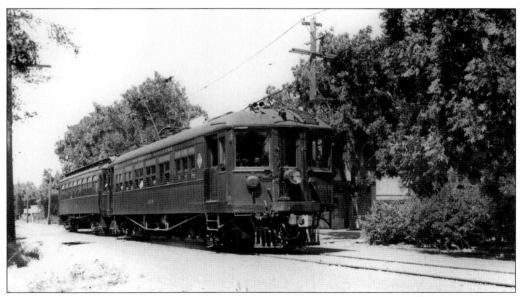

No. 1016 heads a two-car train through Live Oak at about 1:15 p.m., running from Chico to San Francisco in 1940. South End motors, with their dual voltages and detachable third rail shoes, could run on both ends of the SN, although the shoes had to be removed in Sacramento for the trip to Oakland.

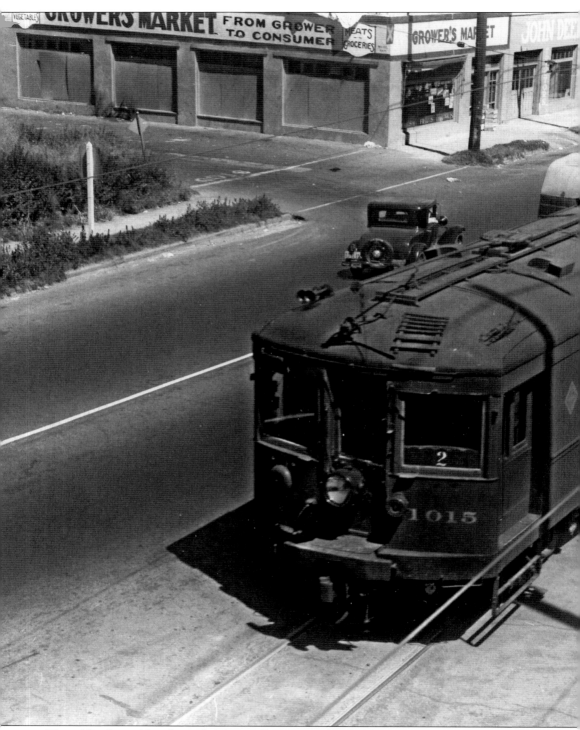

Train No. 2 rumbles through Marysville in 1939, headed by No. 1015. While in retrospect interurban street running may appear picturesque, the trains were restricted to 12 miles per hour

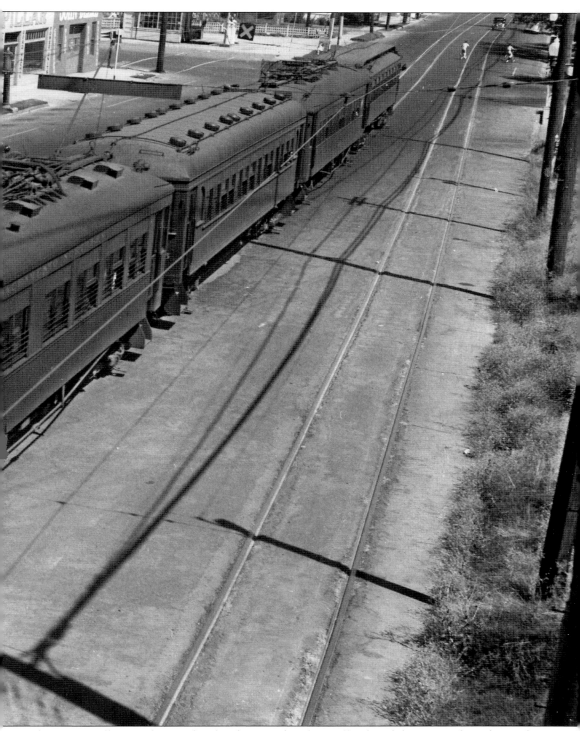

within Marysville's city limits, thus hindering vehicular traffic that didn't exist when the road was constructed.

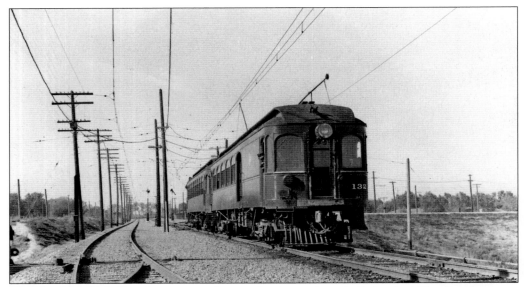

The North End's hallmark cars were the wooden interurbans built by the Niles Car Company in Ohio. With arched windows, railroad-type roofs, and stately lines, these cars were an esthetic asset to any road that owned them. This scene was near Marysville in 1939 as Train No. 7 races to Sacramento.

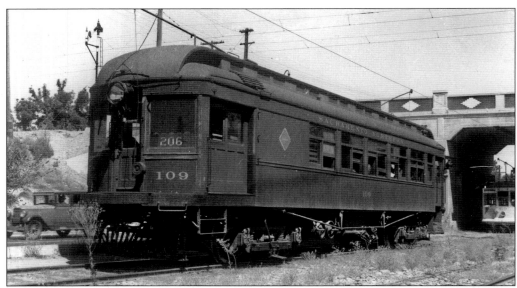

The time is about 12:30 p.m. in 1939 as No. 109, built by the St. Louis Car Company, is in Marysville passing under the Western Pacific Railroad bridge—its main line to Yuba City. Note SN streetcar No. 69, under the bridge, sharing the rails with the 43-ton interurban. The plaque on the side of No. 109 signifies the Railway Express Agency, the UPS and FedEx of its day.

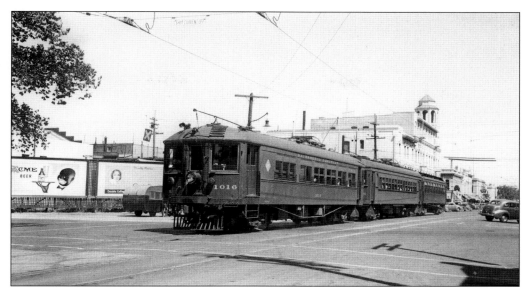

In 1940, Train No. 7, en route to San Francisco, rolls on the streets of Marysville. The billboard advertisement alone indicates how times have changed, even in a county seat in California's Sacramento Valley.

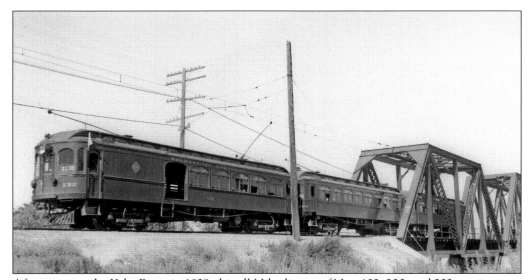

After crossing the Yuba River in 1939, this all-Niles lineup of Nos. 132, 200, and 233 continues to roll over another one of the Sacramento Northern's numerous trestles. The trestles were necessary to maintain a level track and to avoid flooding from winter rains and early snow melts.

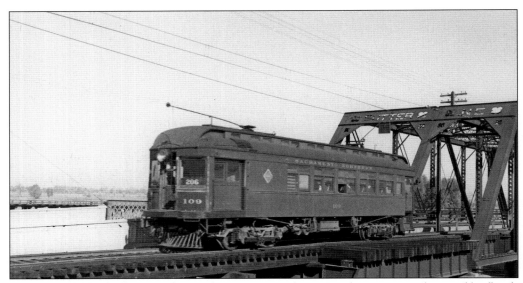

The NE built this bridge over the Feather River to replace an earlier structure damaged by floods in 1907. The four-leaf clovers are symbols of the NE and the lettering "SUTTER" on the bridge signifies the Sutter County line. The bridge remained in use until Christmas 1955 when it was also damaged by floods.

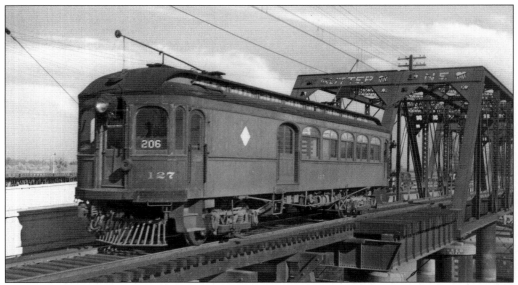

This similarity of the same scene as above contrasts just how handsome the Niles cars, or their facsimiles, were in contrast to other car builders. The No. 109, in the top photograph, was built by St. Louis Car Company while No. 127, above, was a copy built at Mulberry.

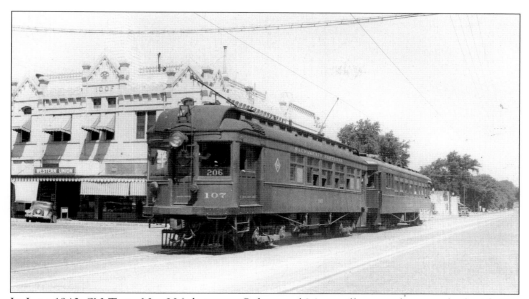

In June 1940, SN Train No. 206, between Colusa and Marysville, was photographed with No. 107 at the head end. Nos. 106–109 were originally made for the Philadelphia & Western in 1906, but the P&W went bankrupt and four of the cars went to the NE instead. The United Railroads of San Francisco received twelve others in this group for the San Mateo Line.

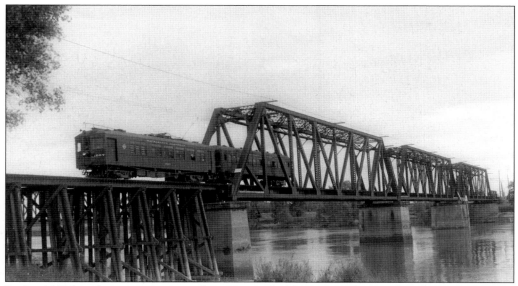

In this 1940 bucolic scene, passenger-baggage combo No. 1007 and control trailer No. 1025 cross over the American River in Sacramento while en route to Marysville and Chico.

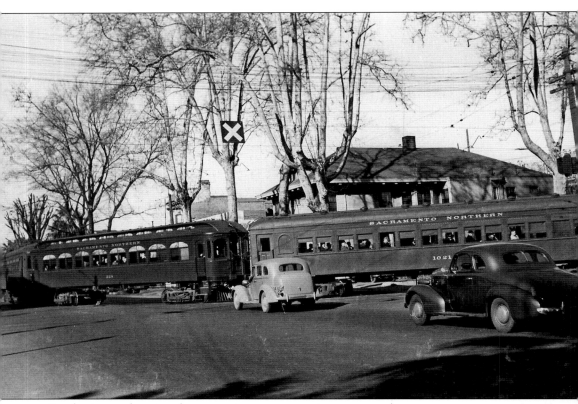

In the interurbans' early years, city street running was an advantage over steam trains. As automobiles proliferated, however, attitudes changed and former passengers who were now driving cars considered the big electrics bothersome. This scene was in Sacramento in 1939. (Courtesy the late Stephen D. Maguire, author's collection.)

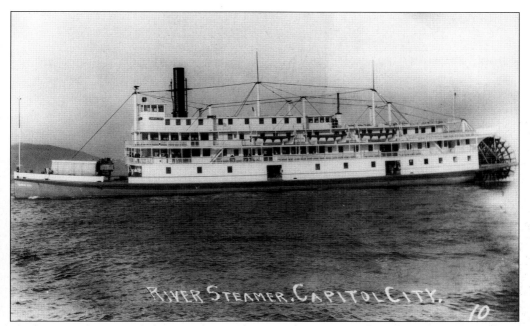

In the initial years of the Northern Electric, there were no connecting interurbans between Sacramento and Oakland–San Francisco. This void was filled by connecting to the California Transportation Company's Sacramento River boats, one of which was the *Capital City*, shown here.

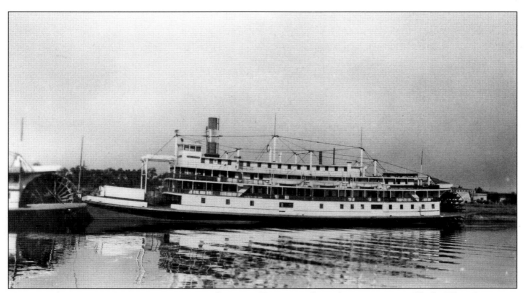

A special train to Sacramento's riverfront at Front and M Streets was called "The Steamer Special," arriving at 6:30 p.m. to catch the night boat to San Francisco. Passengers could also take a night boat, such as the *Fort Sutter*, from San Francisco to Sacramento, board the NE's orange interurbans, and arrive in Chico at 11:20 a.m.

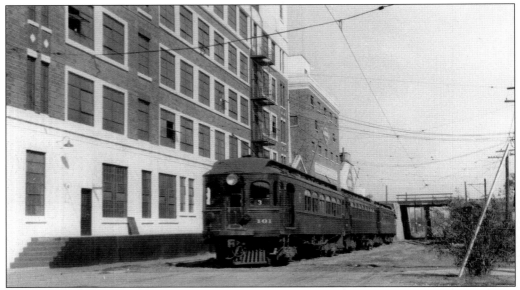

In 1939, Train No. 3, the first of three daily trains to San Francisco, arrives in Sacramento, jokingly referred to in those days by San Franciscans as "Sack o' Tomatoes." Next stop will be the interurbans' Union Station at Twelfth and H Streets.

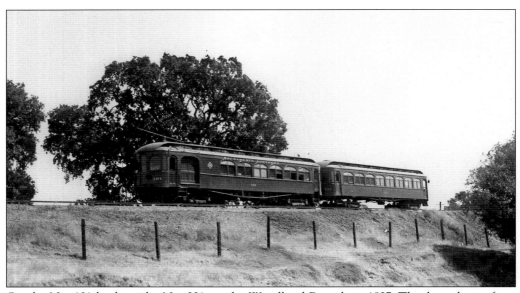

Combo No. 101 leads trailer No. 221 on the Woodland Branch in 1937. This branch ran from Sacramento to Woodland via Lovdal, Beatrix, and Elkhorn. The trolley poles are down and the train is using the electrified third rail, rated at 600 volts DC.

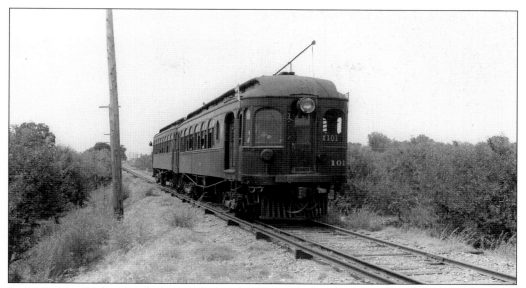

In 1940, No. 101 heads a brace of Niles cars at Rose Orchard on the Woodland Branch, about 3.7 miles northwest of Sacramento. The photograph shows the shoes extending from the trucks and riding on top of the third rails, picking up power for the motors.

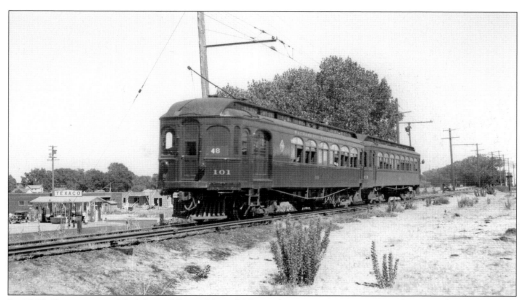

In 1939, Sacramento Northern Nos. 101 and 221 make up Train No. 48 on the Woodland Branch, passing through Broderick on the west bank of the Sacramento River across from Sacramento, the state capital. Today the Woodland Branch is home to the Sacramento River Train.

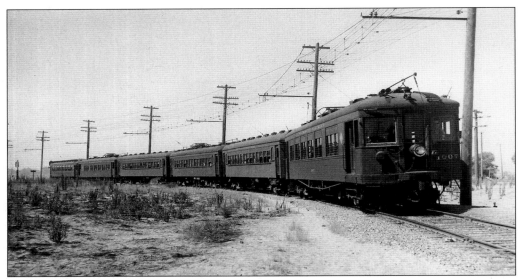

The Cincinnati Car Company built Nos. 1007–1010 for the Oakland, Antioch, & Eastern in 1912, and in this photograph, taken long after the 1929 merger, No. 1007 heads a six-car train in Broderick on the west side of the Sacramento River.

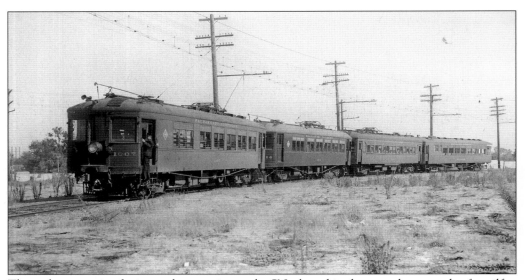

The end was nearing for interurban service on the SN when this photograph was made of a railfan excursion train featuring cars from four different car builders, including the South End's 40th and Shafter Shops. The parlor car *Sacramento* ordinarily did not run on branch lines.

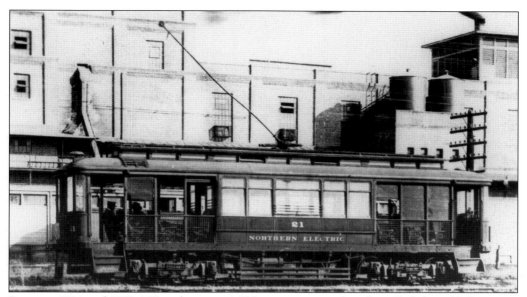

Between 1914 and 1932, NE and successor SN ran a streetcar line from Eighth and J Streets in Sacramento to Swanston. Revenue never justified the line, but a land developer subsidized it to promote real estate sales. In this photograph, No. 21 is in Swanston, north of the American River from Sacramento.

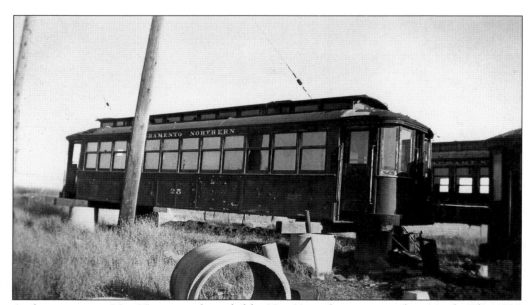

At first, streetcar No. 25 appeared much like No. 21 in the previous photograph. The 1923 rebuilding enclosed the car with only the front ends and roofs unchanged. They acquired the nickname "Elverta Scoots" because they ran on a suburban line to Elverta, north of Sacramento. In this 1940 photograph, No. 25 has been dismantled and is in Chico awaiting demolition.

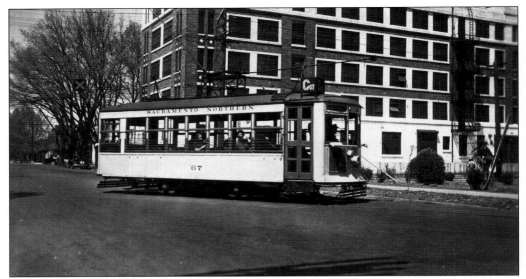

On April 17, 1938, SN Birney No. 67 rounded a curve in Sacramento. No. 67, built in 1920, began as No. 310 on the San Diego Electric Railways, and in 1923, along with six sister cars, was sold to the SN. Lightweight and economical, they were bereft of any creature comforts as they bounced along city streets.

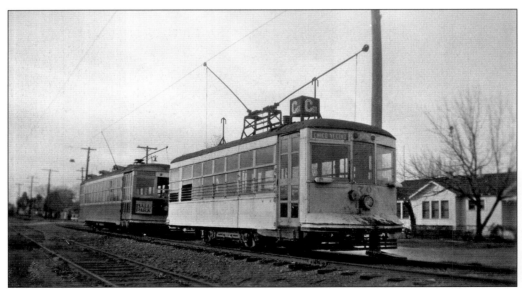

Seen on January 20, 1946, is a railfan excursion in Sacramento using Sacramento City Lines' Nos. 88 and 70 out to Colonial Heights, which explains why ex-SN 70 is signed for both the Sacramento C Street Line and Chico Vecino—90 miles apart. In 1944, Sacramento City Lines bought all streetcar operations in Sacramento.

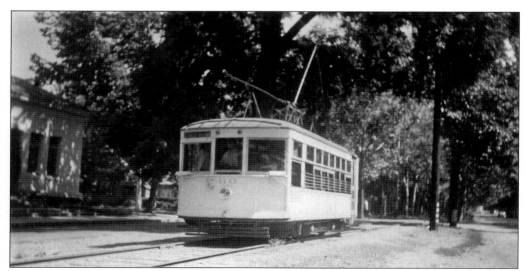

These diminutive cars were called Birneys, after their developer, Charles O. Birney. They were equipped with dead-man controls, operated by one man, were lightweight, used less power, and were intended for lightly used lines. The tower on the roof enabled the trolley poles to reach the overhead wires.

Sacramento Northern streetcar No. 60 tolls along The Esplanade toward Chico Vecino from Twenty-second and Mulberry Streets along Mulberry, Del Norte, Sixteenth Street, Broadway, Fifth Street, and Main Street. Interestingly, it was this line, built by the Chico Electric Railway Company in 1904–1905, which gave the NE the franchise to run in Chico.

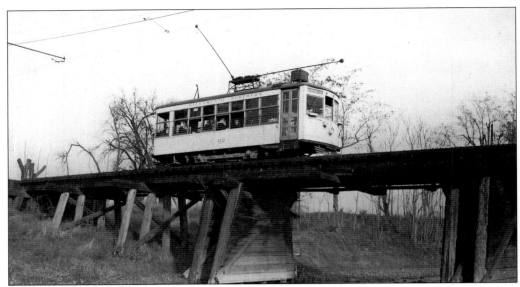

Shown approaching the bridge over the Feather River to Marysville from Yuba City, the SN Birney No. 62 was built by American Car Company of St. Louis in 1920 for the San Diego Electric Railways, coming to the SN in 1923. No. 62 made its final run in Chico on December 15, 1947, to become the last 5¢ a ride streetcar in California. Today No. 62 resides at the Western Railway Museum. (Courtesy the late Stephen D. Maguire, author's collection.)

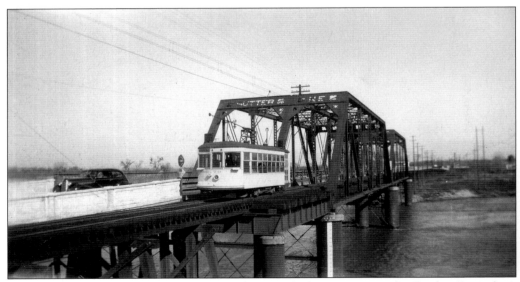

Sacramento Northern streetcar No. 70 is photographed crossing over the Feather River from Marysville to Yuba City. Sacramento Northern streetcars often shared the rails with their big brother interurbans, even to the point of having temporary third rail shoes attached for a trip to the Mulberry Shops for servicing.

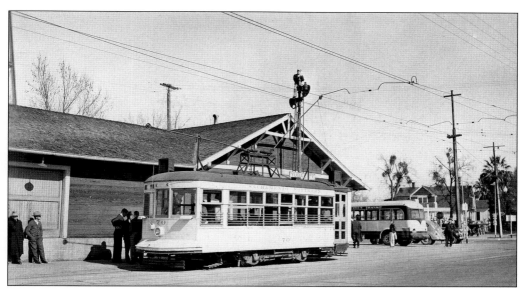

Sacramento Northern streetcar No. 70 is at the Yuba City depot during a layover while the motorman chats with a couple of young men. In partial view is one of the buses that will replace streetcar services on February 16, 1942.

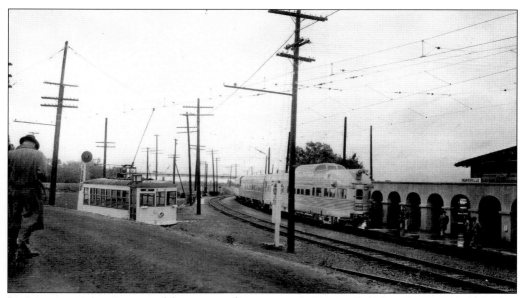

In times past, it wasn't unusual for streetcar lines to terminate at railroad stations, and in this view SN's No. 62 has a meet with the Western Pacific's *California Zephyr* in Marysville. On Sunday, January 21, 1951, SN No. 62 made what was then thought to be the last streetcar trip from the Ferry Building in San Francisco on a railfan excursion. Streetcars returned to the Ferry in 2001, with the opening of the F-line extension to Fisherman's Wharf.

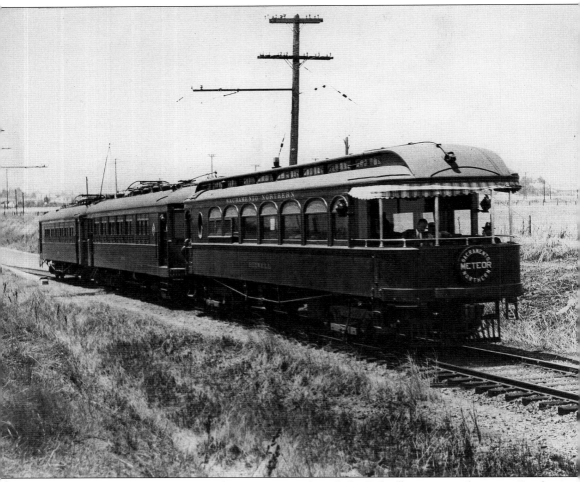

A three-car train consisting of Nos. 1014, 1005, and the *Bidwell* is running between Pittsburg and Port Chicago as the *Meteor*, but the year is 1941 and the SN's interurbans are on borrowed time. At this writing, No. 1005 is being restored at the Western Railway Museum's shops and the museum has begun preliminary work to restore the *Bidwell*. (Courtesy the late Stephen D. Maguire, author's collection.)

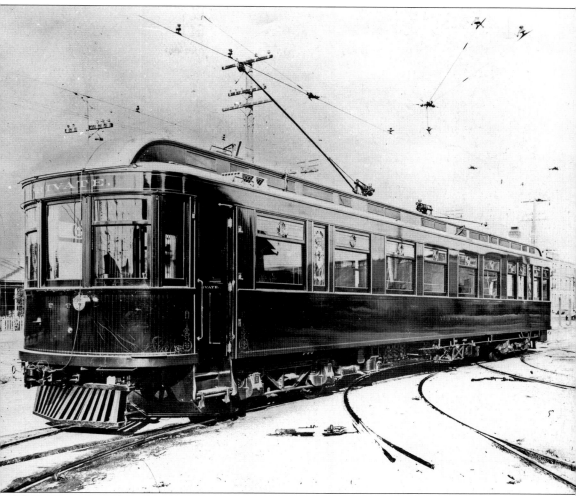

There was a time when the ultimate status symbol was a privately owned railroad car. The most luxurious private interurban car was the *Alabama* at 63 feet, 1 inch long, and fitted with two staterooms, a fireplace, a dining room for 10, hot and cold running water, and a lounge. With four 200-horsepower motors, the *Alabama* was capable of going 120 miles per hour. Owned by Southern Pacific heir Henry E. Huntington to run on his extensive Pacific Electric Railway in southern California, the car could also travel as a trailer on any steam railroad as well. The *Alabama* was sold to the SN in 1921.

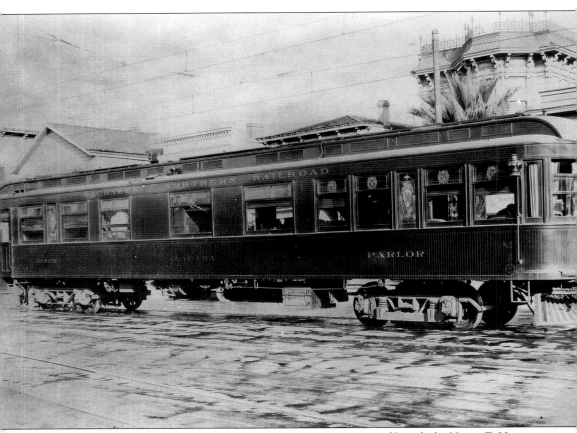

The *Alabama* was built in 1904 by the St. Louis Car Company and bought by Henry E. Huntington to take him from his palatial estate in San Marino to the Huntington Building at Sixth and Main Streets in Los Angeles, as well as for inspection trips over the Pacific Electric Railway. In 1921, the car was sold to the Sacramento Northern and refitted as a parlor car for through service between Chico and Oakland. Unfortunately, the *Alabama* was destroyed in a fire caused by a short circuit to a coffee maker on March 22, 1931, at Dozier Milepost 65.55, too distant from any fire-fighting services.

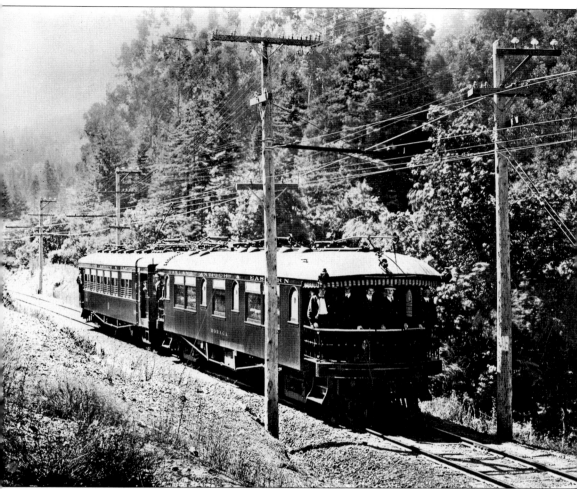

The scene is Redwood Canyon, the year is 1915, and No. 1015 is leading parlor car *Moraga* on a stockholders special. General manager Harry A. Mitchell is on the rear platform at the right. The future looked bright for the railroad that day.

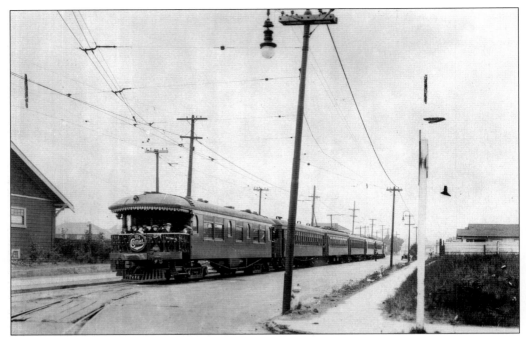

The OA&E was in the parlor car business from the start, using the *Moraga*, a 1913 Wason product. Originally *Moraga* had open platforms at both ends due to the inability to turn the cars around at Sacramento. In 1915, it was demotorized but retained the controls for back-up purposes. In 1927, with the building of the Union Station and its loop tracks, *Moraga* became single-ended. In this 1920s view, *Moraga* is on the rear end of the *Comet*. (Courtesy the late Charles A. Smallwood, author's collection.)

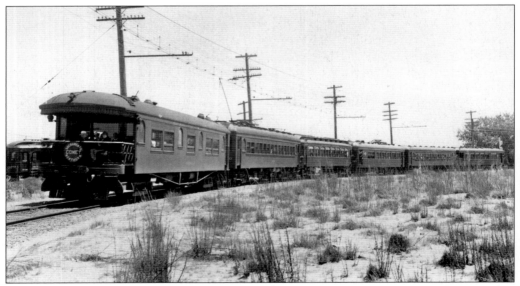

In 1939, *Moraga* was photographed at Broderick on the rear end of a six-car train featuring five different car builders. The Sacramento Northern Railway's middle name must have been "variety." In the left background is Niles-built No. 101.

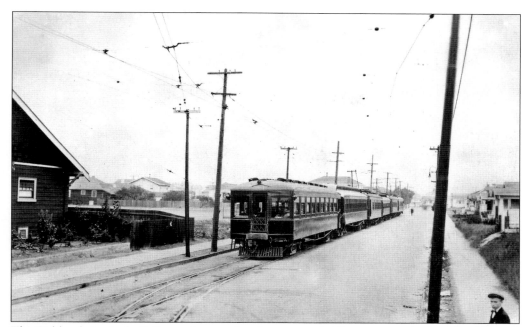

The Oakland, Antioch, & Eastern's second parlor car was the *Sacramento*, rebuilt at the 40th and Shafter Shops from the first No. 1016 I in 1913. This photograph was taken in 1920 on Shafter Avenue. The *Sacramento* would be rebuilt after the 1928 merger with the North End. (Courtesy the late Charles A. Smallwood, author's collection.)

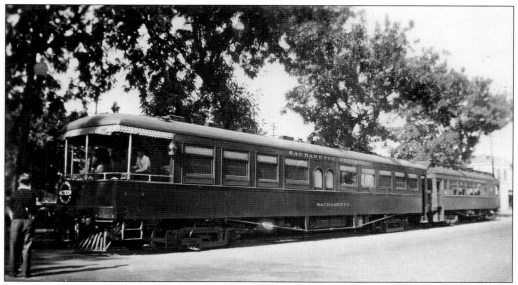

In 1921, the San Francisco–Sacramento Railroad and Sacramento Northern Railroad upgraded their through services between Oakland and Chico, and the *Sacramento* again went into the 40th and Shafter Shops, this time to emerge with a kitchen, pantry, dining section, and open observation platform, as well as being lengthened from 58 feet, 5 inches to 66 feet.

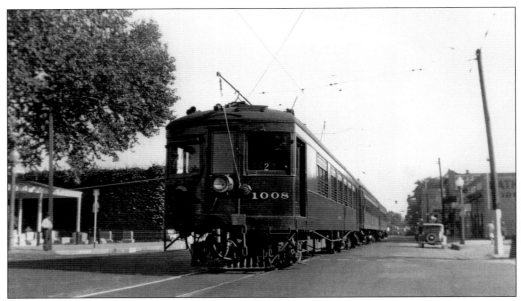

The Sacramento Northern's companion train to the *Meteor* was the *Comet,* pictured here arriving in Chico about 2:00 p.m. in 1939. The No. 1008 has third rail shoes attached to the trucks for North End operation and the trolley poles now have carbon shoes, or slides, instead of brass grooved wheels for electrical contact.

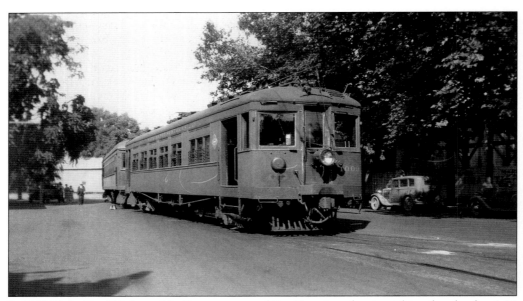

In 1939, Train No. 11 is bound for Sacramento and San Francisco, leaving Chico shortly after 4:00 p.m. Note how No. 1009's windows are open, indicating that it's probably another hot summer afternoon in the Sacramento Valley, before the days of air conditioning.

Two

THE SOUTH END

The South End of the Sacramento Northern began as the Oakland & Antioch Railway in 1911, and when the line was completed to Sacramento in 1913 it became the Oakland, Antioch, & Eastern Railway (OA&E). In 1920, after a foreclosure sale, it became the San Francisco–Sacramento Railway. On December 31, 1928, the SF-S Railway merged with the North End to become the Sacramento Northern Railway.

The South End had both 1,200- and 1,500-volt systems, and also operated on 600 volts while in Key System territory. The South End had the steep grades while the North End was relatively flat. The South End was under the catenary while the North end used third rails, except in cities or towns. The South End had no streetcars but it did have a ferryboat.

Because South End equipment could be used on both ends and North End rolling stock could not, South End cars became quite at home on the North End. And since parlor car services had been operated by both of the prior companies, it made for quite a mix.

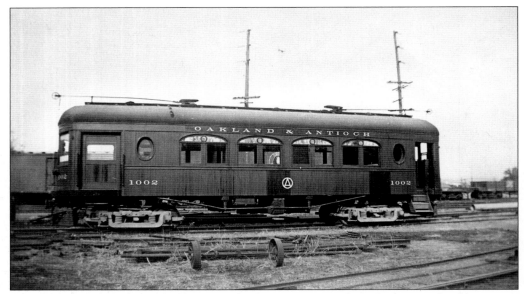

Over the years, the relationship between the Sacramento Northern Railway and railfan groups was very friendly. Thus in 1939, Mulberry Shops restored No. 1002, built in 1911 for the original Oakland & Antioch, to its nearly original appearance for a railfan excursion.

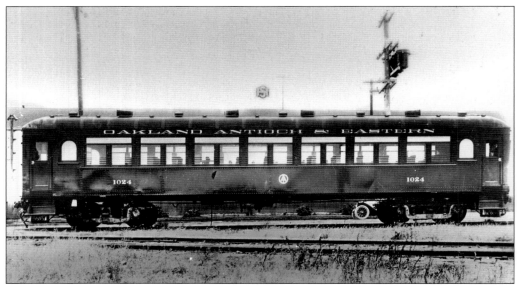

This photograph shows how the Hall Scott cars originally looked in 1913 in their Oakland, Antioch, & Eastern livery of Pullman green with gold lettering. Northern Electric cars were originally painted orange, but adopted a dark green with gold lettering in 1918 when the NE became the Sacramento Northern Railroad.

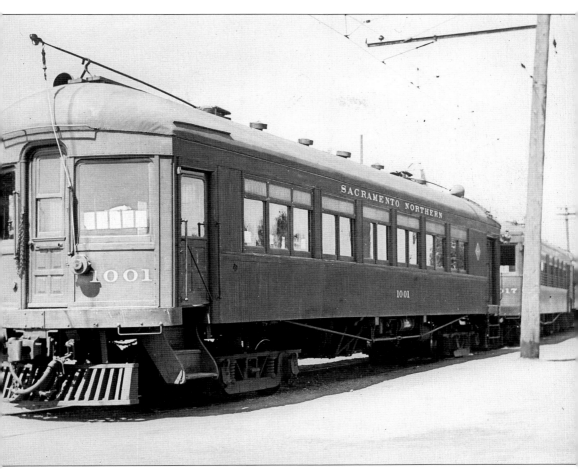

The South End of the SN was first named the Oakland & Antioch Railway, but became the Oakland, Antioch, & Eastern Railway even though the road never reached Antioch itself. The Holman Car Company of San Francisco built the first two interurban cars for the O&A in 1911, numbered 1001 and 1002. Shown above is No. 1001, rebuilt in 1913, pulling two trailers.

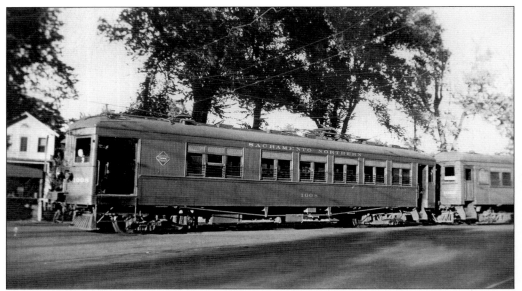

Nos. 1008 and 1023 make up Train No. 9 in Sacramento's Union Station in the mid-1930s. Train No. 9 will leave Sacramento at 4:46 p.m. and arrive in Oakland at 7:22 p.m., followed by a trip to the Key System Pier and a ferry ride across San Francisco Bay to the famed Ferry Building.

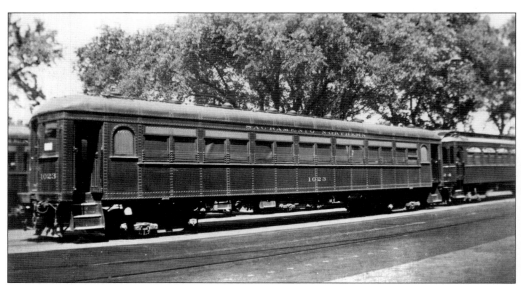

In this photograph taken in Sacramento, Hall Scott trailer No. 1023 is coupled to Niles-built trailer No. 224. This is odd since the SN usually coupled trailers to motorized cars.

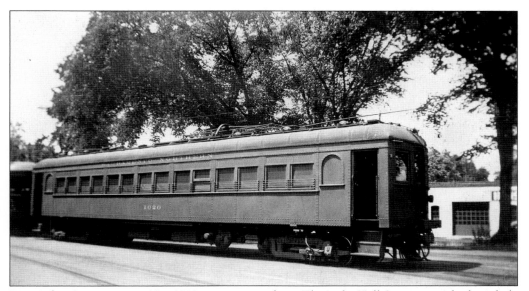

Pictured in Sacramento is No. 1020 as a motorized car. The eight Hall Scott cars, which include No. 1020, were the only all-steel cars on the Sacramento Northern roster. No. 1020 was relegated to maintenance-of-way use after 1941, becoming MW 302.

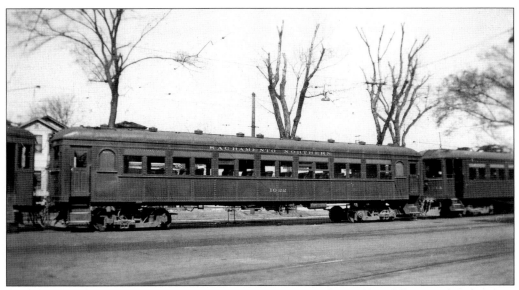

Hall Scott-built trailer No. 1022 spent its entire career as a trailer. In 1941, following abandonment of SN interurban services, it went to the Western Pacific Railroad to begin a new career in branch line service for the WP.

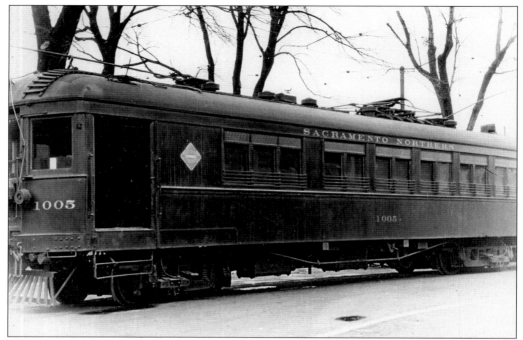

The No. 1005, without a train number, lays over in Sacramento. Sporting third rail shoes, trolley poles, and a pantograph, plus a switch enabling the car to run on either 600 or 1,200 volts DC, the No. 1005 could go anywhere on the main line from Oakland to Chico. At this writing, it is in the Western Railway Museum shops in Solano County, undergoing a complete restoration.

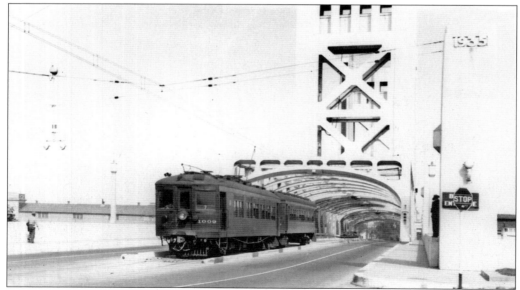

About 2:49 p.m., a brace of SN interurbans enters Sacramento over the M Street Bridge, now Tower Bridge. Today Tower Bridge supports one-way vehicular traffic off Interstate 80. When this photograph was taken in 1939, Sacramento was still very much a river town, enlivened only when the California legislature was in session.

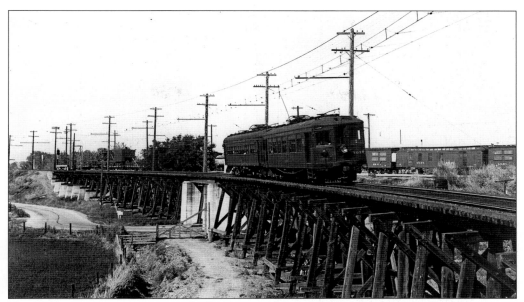

No. 1017 leads a two-car train over the Riverview trestle, a tad short of seven miles from Sacramento in this 1930s setting. In the background is the maintenance-of-way (MOW) that consists of MW 298, No. 90, and an unidentified MOW car. Usually recycled older cars that had seen better days, MOW cars were nevertheless vital in keeping the railroad up to scratch. No. 90 was built by the Pennsylvania Railroad in 1895, came to the NE in 1907, went into MOW duty in 1930, and was scrapped in 1935.

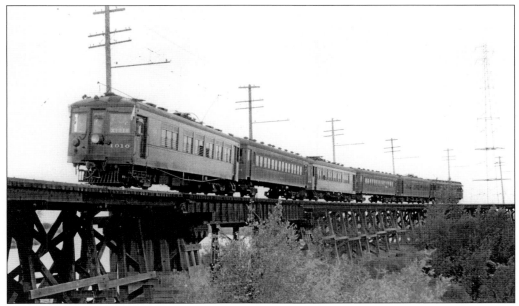

No. 1010, running as an extra and towing the parlor car *Bidwell*, is probably working a railfan charter at Arcade in 1940. Relations between the Sacramento Northern and railfan groups were very good, and charters over the SN were well attended.

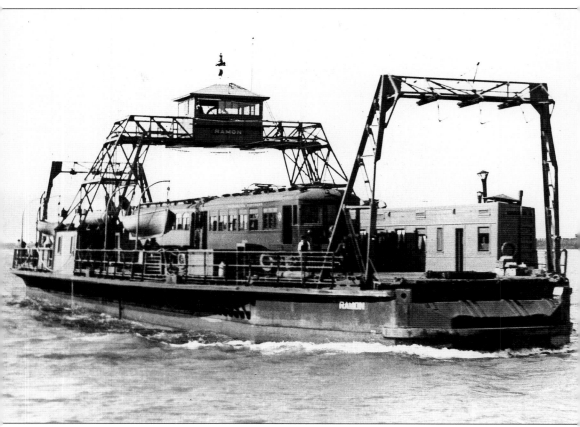

The *Ramon* was the ugly duckling of San Francisco Bay ferries, with no curves in her hull. Powered by a distillate engine, it sometimes took full engine power to fight heavy tides and strong winds. She gave 40 years of service before being decommissioned in 1954. The end of the *Ramon* hastened the end of SN's electrics and meant eventual conversion to all diesel-electric locomotives. (Courtesy the late Stephen D. Maguire, author's collection.)

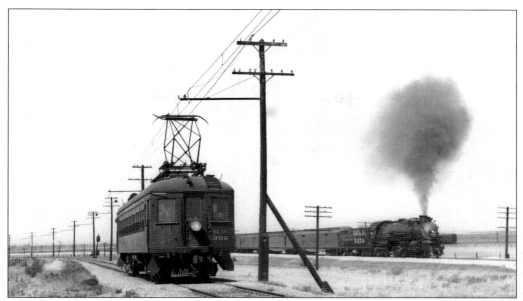

When the SN gave up its interurbans in 1941, Nos. 1019 and 1020 were kept for maintenance-of-way duties. In this 1948 photograph, MW 302, ex-1020, is at Port Chicago as Santa Fe No. 3459 belches a plume of black smoke—a rail photographer's delight. Today MW 302 has been restored as OA&E 1020 and serves at the Western Railway Museum.

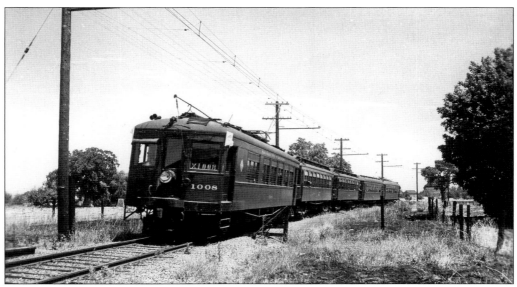

During the 1930s, as interurban abandonments were either occurring or imminent, the railfan fraternity began to coalesce into organizations of varying formalities and chartered special trains to take and exchange photographs, memorabilia, and souvenirs. On July 14, 1940, SN's 1008 leads a five-car extra train at Pleasant Hill.

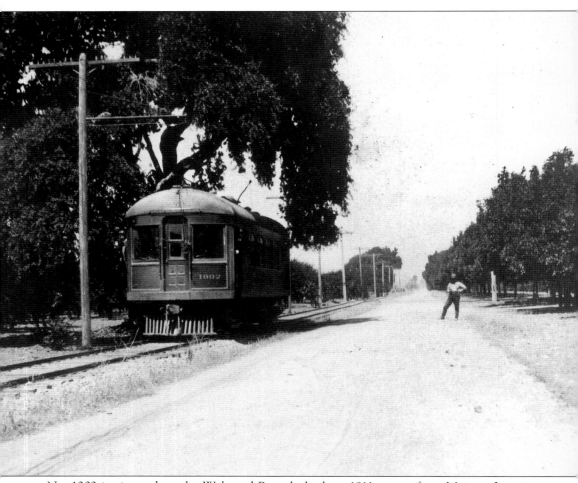

No. 1002 is pictured on the Walwood Branch, built in 1911 to run from Meinert Junction to Walwood, 2.8 miles long. Originally, the O&A had hoped to develop a tourist trade to Mount Diablo, but this never materialized. Low patronage caused the line to be reduced to one mixed train daily, and final abandonment came in 1920. This scene is between Meinert and Gavin.

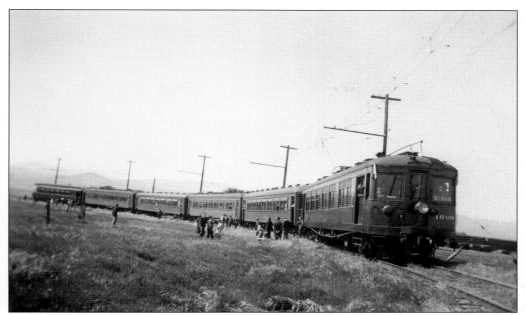

On railfan excursions, one of the highlights is to let passengers off the train while it backs up, then moves forward again for the benefit of rail photography. This movement is known as a "run by." In this photograph, No. 1009 heads a six-car special trailed by parlor car *Bidwell*.

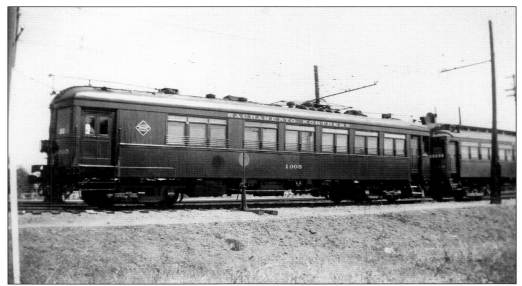

SN No. 1005 exists today because it was one of five SN interurbans deeded to the California Toll Bridge Authority as compensation for the building of the railway on the San Francisco–Oakland Bay Bridge. After abandonment, the state sold the quintet to a junk dealer who, in turn, sold them to the Key System. In 1951, the Key System sold No. 1005 to the Bay Area Railroad Association for its future museum.

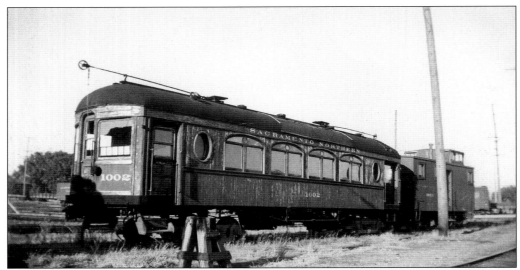

At 44 feet, 8 inches, Nos. 1001 and 1002 were the shortest interurbans on the SN. No. 1002, above, was rebuilt in 1914 into an inspection car, receiving a kitchen, dining section, sleeping section, and offices. In 1914, No. 1002 was again rebuilt into a passenger-baggage combo car and spent most of its career on the lightly patronized Pittsburg Branch. Weather beaten and forlorn, No. 1002 sits outside Mulberry, coupled to caboose 1613.

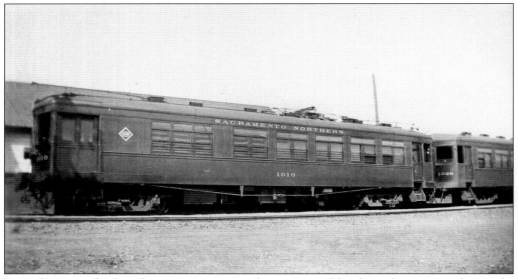

From the outset, both ends were aggressive in the carrying of freight and express, and carried a red plaque reading "RAILWAY EXPRESS AGENCY," meaning they were part of a nationwide express service. Moreover, baggage sections were expanded to make more room for express parcels—at the expense of seating. No. 1010, above, actually had half of the car devoted to its baggage-express section.

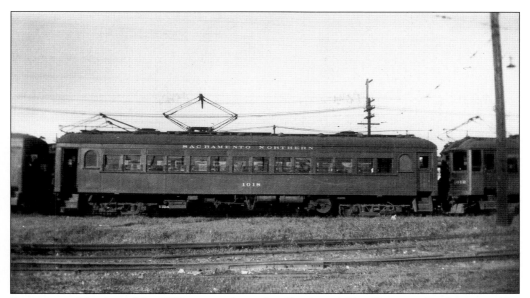

Sacramento Northern No. 1018, center, from the Cincinnati Car Company, is shown on Key System rails sandwiched behind No. 1012 from Wason. It was not unusual to see cars of different railcar builders in the same train, especially on the South End. North End cars were almost entirely from the Niles Car Company.

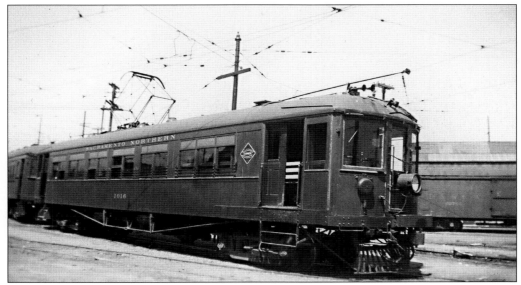

OA&E's original No. 1016 was built by the Cincinnati Car Company as a trailer, but upon delivery was rebuilt in the 40th and Shafter Shops into the parlor car *Sacramento*. No. 1013, on the other hand, had so many mechanical problems that in 1914 a superstitious master mechanic renumbered the car from No. 1013 to No. 1016. That must have cured the jinx—1016 II lasted until 1941.

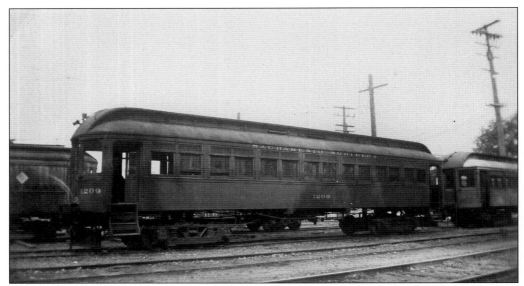

No. 1209 was built in 1907 by Holman for the Ocean Shore Railroad. The OSRR was projected as an interurban connecting San Francisco and Santa Cruz, but never lived up to expectations and made its last run in 1920. The OA&E purchased Nos. 1208–1210 from the OSRR in 1916, and No. 1209 went to the torch in 1941.

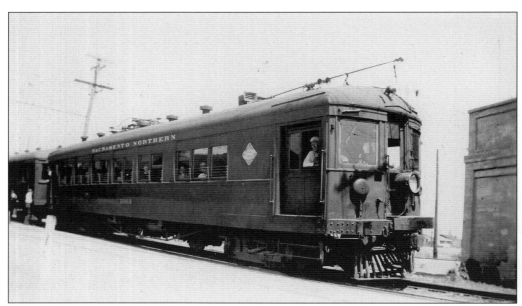

Nos. 1003–1006 were built in 1912 with the South End interurbans' signature look. Rather square in front, and never as graceful as the North End's Niles cars, they were a style unique to the SN. Here the motorman of No. 1003 takes the time to pose with his train.

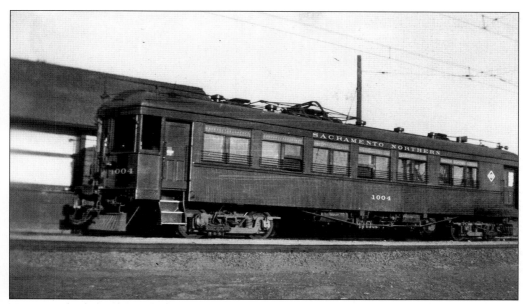

No. 1004, built by the Holman Car Company in San Francisco, is pictured with both trolley poles and the pantograph down, waiting for another assignment. After abandonment of the SN interurbans in 1941, most of the cars were burned at Mulberry with the metal being sold for scrap.

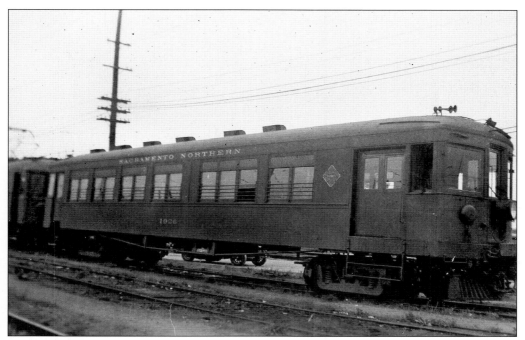

In 1913, the Cincinnati Car Company built this car as No. 1018, but in 1928 Nos. 1018 and 1026 exchanged numbers in order to keep trailers and motors within proper numbering blocs. As 1026 II, the car was unique in that it was a combo trailer, having a baggage-express section similar to No. 1017.

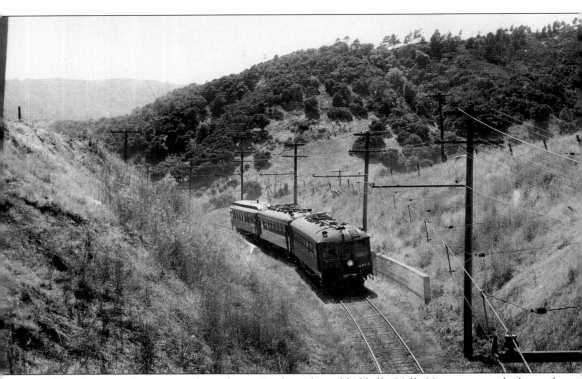

With its sweeping curves through cuts in the oak-studded hills, Valle Vista was an ideal spot for rail photographers. Any angle seemed to guarantee a good image on film. (Tom Gray photograph, author's collection.)

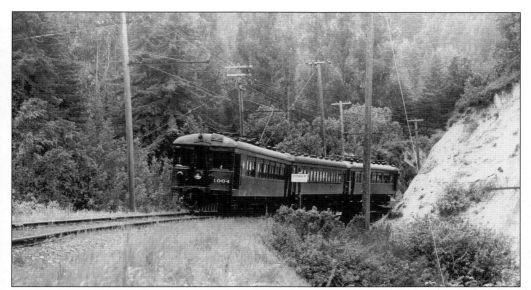

It is about 9:19 a.m. as SN's Train No. 1 is crossing the trestle at Pinehurst on its way to San Francisco. While the year is 1940, it seems that nothing in this sylvan setting has changed since 1913 when this railroad was built as the Oakland, Antioch, & Eastern Railway.

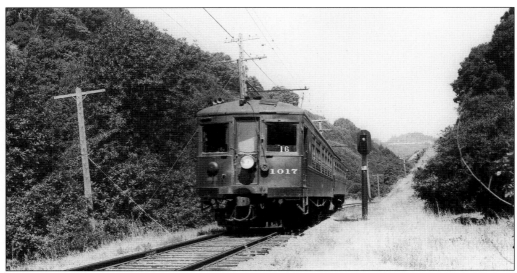

On a Sunday morning in 1939, No. 1017 heads Train No. 16, a local, in Shepherd Canyon while en route from Pittsburg to San Francisco. The Pittsburg locals, largely commuter trains to and from San Francisco, both predated and outlasted the Oakland-Sacramento trains.

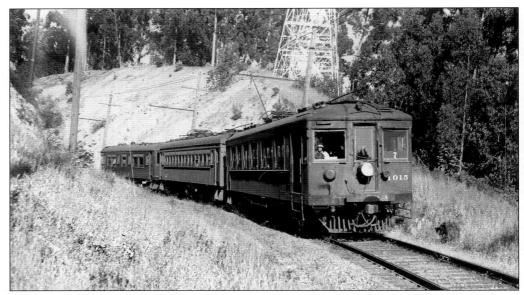

Train No. 7, westbound to Oakland, has emerged from the SN's only tunnel. The four traction motors on No. 1015 are going full tilt as the train works its way to Shepherd Canyon.

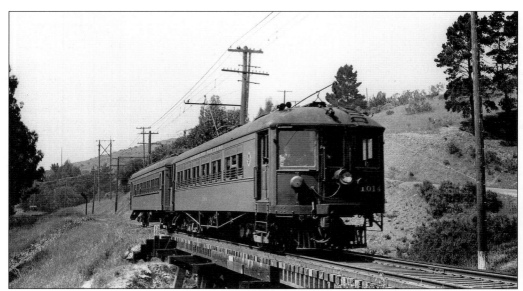

This was the scene just east of Rockridge in 1940 as Train No. 6, eastbound, starts to cross one of the Sacramento Northern's innumerable trestles. On the SN, eastbound was going away from San Francisco while westbound was toward San Francisco, regardless of the compass.

Sacramento Short Line"

AUTO STAGE CONNECTIONS

AT SACRAMENTO

rce Arrow Stage for Folsom, Clarksville, Shingle Springs, Eldorado, wville and Camino. Ask agents for information.
w week-end fares.

AT RIO VISTA JUNCTION

Vista Transit Co. for Rio Vista connects with trains Nos. 6, 9, 2, 11, 12, , 16, 20, 21 and 23.
sleton connects with trains 6, 9, 12, 15, 20 and 21.
w week-end fares.

AT PITTSBURG

ard's Auto Stage for Antioch connects with all trains.
w week-end fares.

AT BAY POINT

rtinez and Bay Point Stage Co. for Martinez connects with trains Nos. 6, 9, 11, 12, 13, 14, 15 and 16.

AT CHICO
FOR RICHARDSON SPRINGS

-year-round resort. Auto Stage leaves Chico daily at 2:00 p. m. rsion tickets sold.

BAGGAGE CHECKED FROM YOUR HOME

ll Franklin 4600, City Transfer Co., San Francisco; Lakeside 969, le's Baggage Co., Oakland; or Main 23, Electric Transfer Co., Sacnto, and tickets for transportation will be delivered promptly when age is called for at hotel or residence.

FAST FREIGHT SERVICE

connection with SANTA FE and SACRAMENTO NORTHERN ROAD from San Francisco to Woodland, Marysville, Yuba City, sa, Oroville and Chico.
vernight freight service from San Francisco via Santa Fe and Bay t to Sacramento and all stations. Through freight rates to and points in California and the East via Southern Pacific, Western fic and Santa Fe.

TICKET OFFICES

FRANCISCO: Key Route Ferry. Phone Sutter 2339.
eck-Judah Co., 672 Market St. Phone Kearny 2751.
genzia Fugazi, Agts., 630 Montgomery St.
hone Kearny 3649.
ames Fugazi & Bulotti, Agts., 57 Columbus Ave.
hone Sutter 4886.

KLAND: Depot 40th and Shafter. Phone Piedmont 345.
A. Beckwith, Agt., 213 Easton Bldg. Phone Oakland 3523.
rabtree's Travel Office, 1325 Broadway. Phone Oakland 1437.
J. Lenehan Agency, 1422 San Pablo Ave. Phone Lakeside 530.

RKELEY:
rabtree's Travel Office, 2121 Shattuck Ave. Phone Thornwall 60
CRAMENTO: Depot, Third and I Sts. Phone Main 6330.
rabtree's Travel Office, 921 K St. Phone Main 5820.

L. H. Rodebaugh, Traffic Manager, 40th and Shafter Ave.
ephone PIEDMONT 345 Oakland, Cal.

General Offices, Hobart Building. Phone Garfield 61
San Francisco

'or convenience of patrons, all trains stop at Third and K Streets, ramento, and at College and Shafter Avenues, Oakland, where contions are made with street cars for Oakland, Alameda and Berkeley.

Form 247– 12420

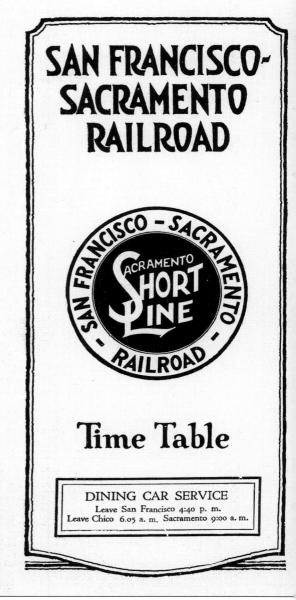

SAN FRANCISCO-SACRAMENTO RAILROAD

Time Table

DINING CAR SERVICE
Leave San Francisco 4:40 p. m.
Leave Chico 6.05 a. m. Sacramento 9:00 a. m.

This 1920s timetable advertises dining car service right on the cover. The inside shows seven trains daily in each direction between San Francisco and Sacramento, covering the 92.9 miles in 3 hours and 15 minutes. The trip included two ferryboat rides.

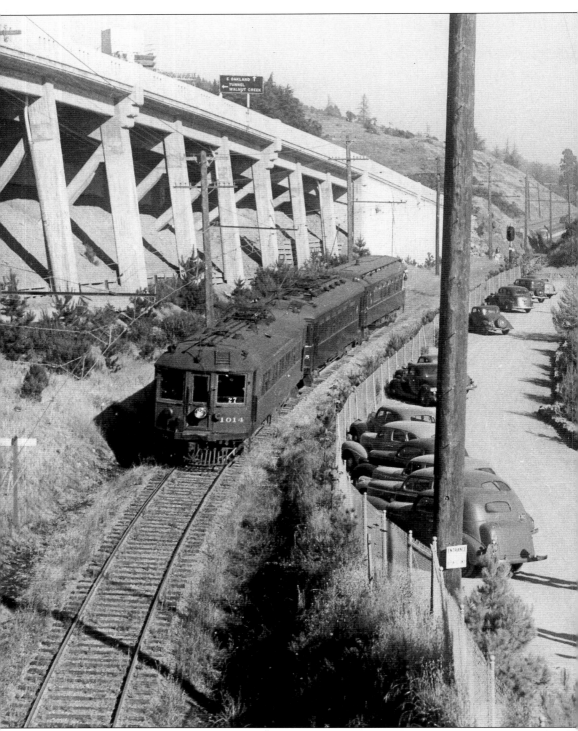

Then, as now, heads turn to watch a train. In this case it is a Concord local, descending past Oakland's Lake Temescal on its way to San Francisco on a bright afternoon in 1940. An interesting

reflection of the times is the sign reading "Parking 10¢." Sad to say, both the electric trains and 10¢ parking are long gone.

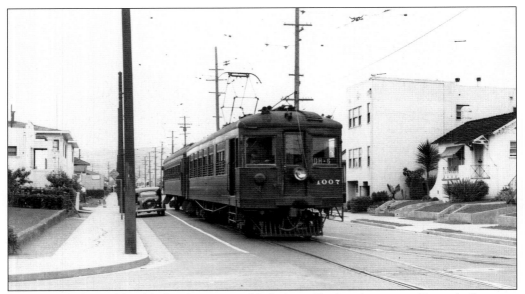

Down from the Oakland hills, the SN rumbled along Shafter Avenue to Fortieth Street in 1940. No. 1007, however, is leading a "deadhead" train to San Francisco's Transbay Terminal to begin an eastbound run. The big interurbans didn't leave much room for driving or parking on Shafter Avenue.

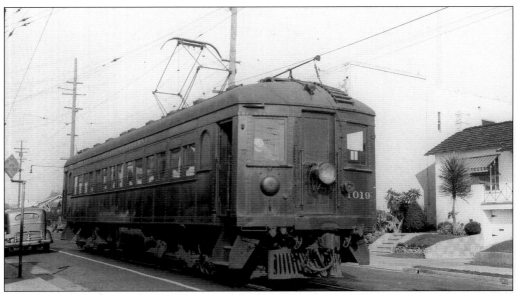

SN No. 1019 was one of eight all-steel trailers built in 1913 by the Hall Scott Motor Car Company of Berkeley. Two years later, three Hall Scotts were motorized, including No. 1019, pictured on October 19, 1939, on Shafter Avenue in Oakland. After the interurbans' abandonment, No. 1019 was kept for company use and renumbered 301. Today No. 1019 awaits restoration at the Western Railway Museum.

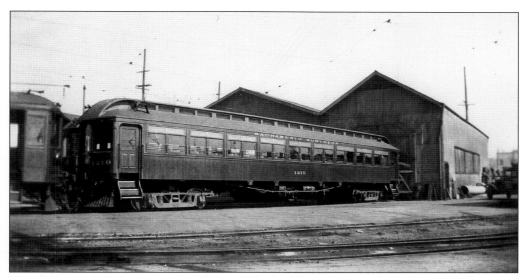

No. 1210 was rebuilt by men at the 40th and Shafter Shop into a much longer trailer, measuring 63 feet, 7 inches. It had 74 seats and was used on school trains in the days when kids had to ride trains to get to high school. In 1941, No. 1210 was scrapped after 34 years on the rails.

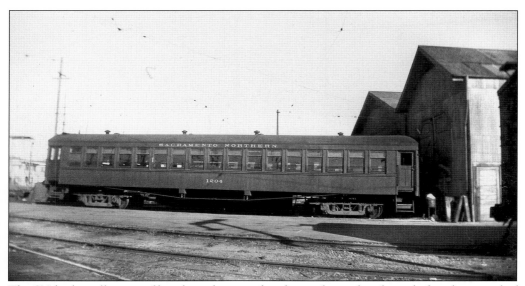

The SN had a collection of hand-me-down trailers from other railroads, and after the arrival of the Hall Scott cars, were used mainly for excursions and heavy traffic to places such as the state fair in Sacramento. No. 1204 was one of six cars from the Southern Pacific thought to have been built in the 1880s. This photograph was taken at the 40th and Shafter Shops.

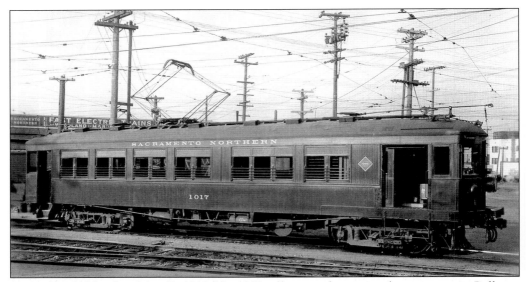

Spotted in Oakland on May 18, 1940, No. 1017 still retained its original appearance in Pullman green. The car was already 27 years old and time was running out. The next year, following abandonment, the car would be destroyed.

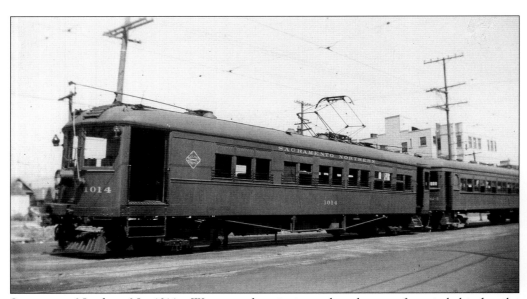

Sacramento Northern No. 1014, a Wason product, is pictured on the rear of a train behind trailer No. 1023 at Fortieth Street and Broadway in Oakland. No. 1023, from Hall Scott, was sold in 1941 to parent Western Pacific, which used it and the other Hall Scott trailers until 1951.

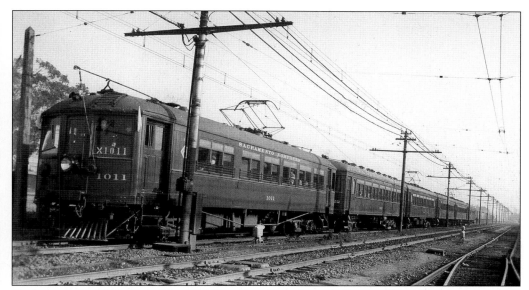

On January 14, 1930, Train No. 1011 Extra is rolling through Emeryville with a six-car consist. It remains unclear why the SN would run an extra train during those difficult economic times and at that time of year.

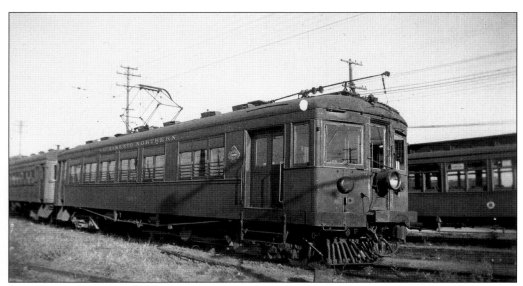

In the early 1930s, No. 1009 was photographed working a two-car train in Key System territory. When on Key System rails, the SN had to use a pantograph for current collection rather than the trolley pole so as to be compatible with the Key's overhead wire system.

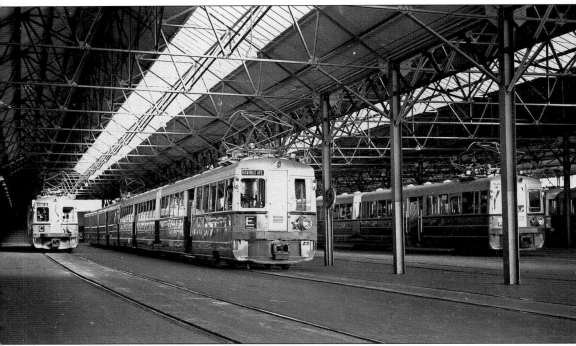

This was the interior of the Key Pier train shed that replaced an earlier one destroyed by a 1933 fire. Photographer and historian Wilbur C. Whittaker photographed the replacement terminal where passengers transferred to and from the trains and ferries around 1937. Pictured are new Key System units built for that company's future Bay Bridge service. During this period of conversion to Bay Bridge service, SN passengers were transported from Fortieth and Shafter to the Key Pier by special Key System units of this type that carried disc signs that read "Sacramento Northern Train." (Wilbur C. Whittaker photograph, author's collection.)

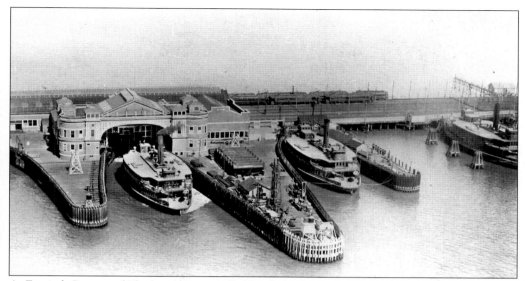

At Fortieth Street and Shafter Avenue in Oakland, the OA&E used the Key Route's rails to arrive at the original Key Pier, shown in this picture. At the pier, passengers boarded the Key's orange ferries to complete their journeys to San Francisco.

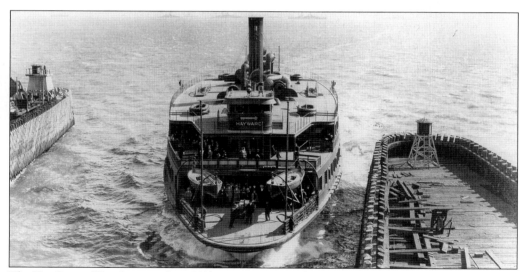

The Key Route (Key System after 1933) steamer *Hayward I* is arriving at the Key Pier in the 1920s. The passenger load crowds the foredecks to get off quickly and catch either a Key Route or SN interurban, the latter to climb the Oakland hills to points east and north.

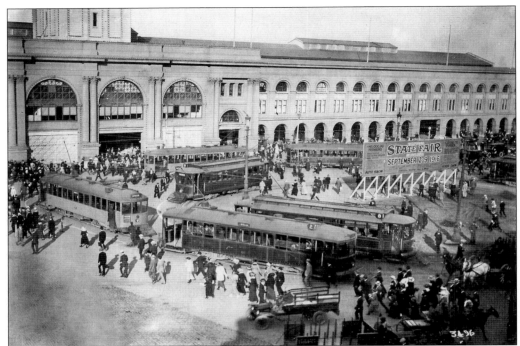

It's 5:12 p.m. on August 21, 1916, in front of San Francisco's Ferry Building as commuters swarm from the city's streetcars in order to catch the ferries for their trips home. It doesn't look as if they're going to be able to catch the Key System's 5:15 ferry. Note the billboard advertising the state fair, opening in less than two weeks. (Courtesy City and County of San Francisco Bureau of Engineering, author's collection.)

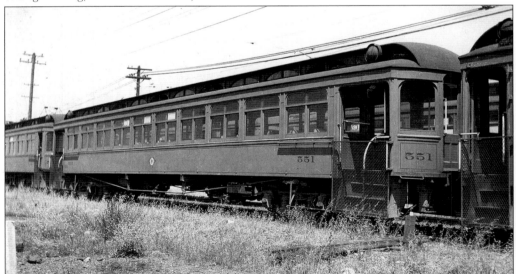

When patronage to the picnic areas in the Oakland hills or to the state fair in Sacramento exceeded the capacity of the South End's own fleet of interurbans, Key Route trailers, such as those shown here, were coupled to the SN freight motors, as had been the practice under former ownership, to provide extra service.

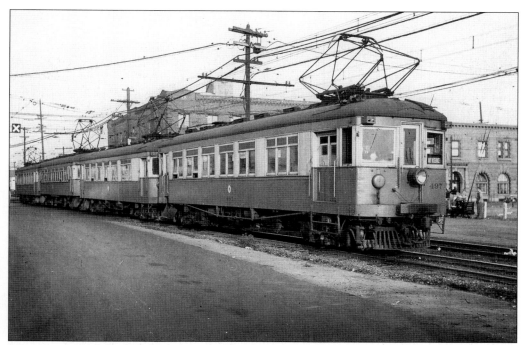

The state wanted the three railways using the Bridge Railway to pay for its construction. However, the railways were money-losers and instead deeded rolling stock to the state as collateral. When the SN ceased its interurbans, the state took ownership of five cars that later went to the Key System. This picture was taken at Fortieth Street and San Pablo in Oakland. (Ken Kidder photograph, author's collection.)

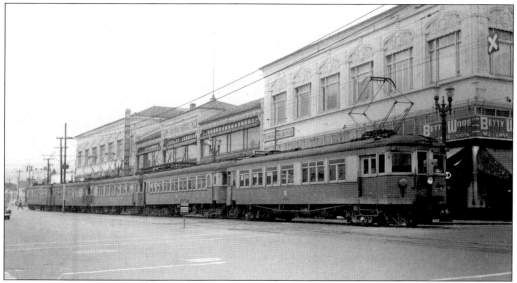

Times have changed since the five SN cars ran together on the Key System and were affectionately called the "City of Berkeley." The Roos Brothers store is gone, the Key's F Route is an A/C Transit bus line, and BART, which replaced parts of the Key and the SN, runs in a subway under where this picture was taken. (Courtesy the late Stephen D. Maguire, author's collection.)

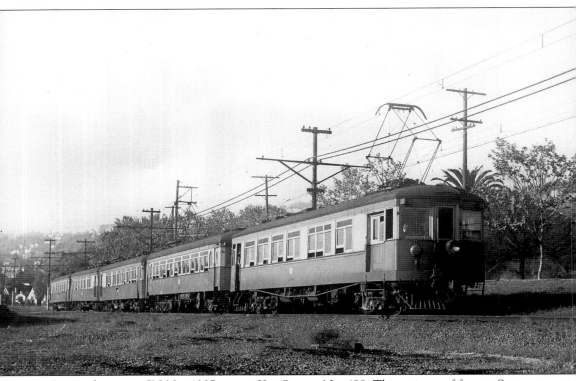

In new livery, ex-SN No. 1005 is now Key System No. 498. This quintet of former Sacramento Northern rolling stock always ran together on one commute trip in each direction each weekday. This photograph was taken by Tom Gray in 1946 when Berkeley still had some open space. (Tom Gray photograph, author's collection.)

Three

TERMINALS AND SHOPS

The terminal and depot facilities of the Sacramento Northern, for the most part, vanished from the earth. This is most unfortunate, for they were a diverse lot and descriptions of them, both in photography and in text, could easily fill a volume in their own right.

Moreover, the two shop facilities of the SN—40th and Shafter in Oakland and Mulberry in Chico—were staffed for decades with very talented craftsmen who could make repairs of all kinds, do rebuildings and conversions, and actually construct from scratch anything from an interurban car, to a freight locomotive, to a non-revenue car. Whether in the cramped quarters at 40th and Shafter or in the spacious facility at Mulberry, these facilities and their denizens saw to it that at least in this particular arena the stockholders got their money's worth.

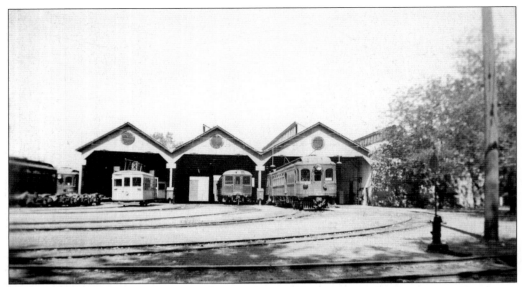

In this photograph, we see five interurbans and a pair of streetcars at the Sacramento Northern's Mulberry carhouse and shops complex, located on Mulberry Street at Chico's city limits. This structure lasted well past the SN's interurban days.

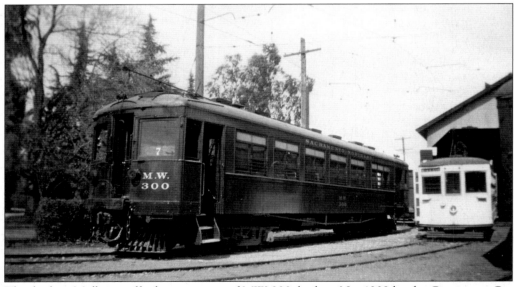

This look at Mulberry affords a rare view of MW 300, built as No. 1009 by the Cincinnati Car Company in 1912 for the Oakland, Antioch, & Eastern Railway. After interurban abandonments, No. 1009 was kept for maintenance-of-way purposes and renumbered as MW 300. In April 1947, the car was stripped of electrical parts and refitted as a kitchen-diner for section gangs and renumbered to MW 80.

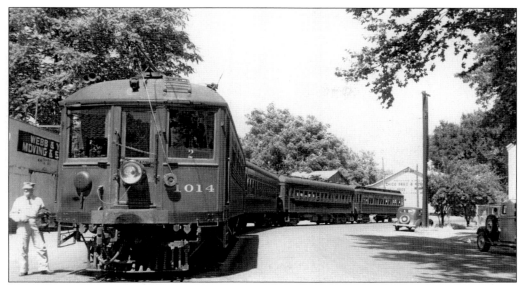

It is 1939 and the time is shortly after 2:00 p.m. The motorman at left has just brought his train into Chico after a six-hour, 185.41-mile journey from San Francisco. The motorman's attire is typical for the SN, including the necktie.

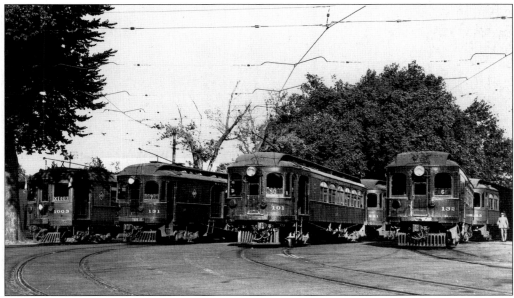

A quartet of Sacramento Northern trains, representing three different car builders, pose for posterity on the loop tracks in back of Sacramento's Union Station, located between H and I Streets (between Eleventh and Twelfth Streets). Trains entered from Twelfth Street and exited on Eleventh Street. The loop tracks avoided switching to reverse the trains for the return trips.

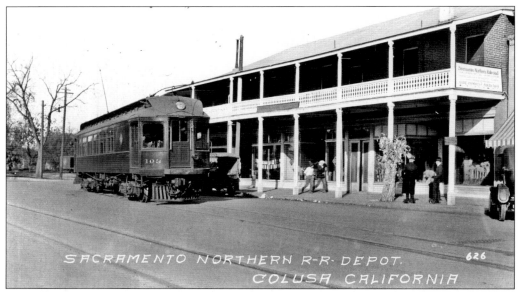

In 1923, passenger-baggage combo No. 103 poses at the SN station in Colusa. The Colusa Branch ran from Marysville to Colusa, running down Market Street to a loop track where the cars reversed direction for the trip back to Marysville.

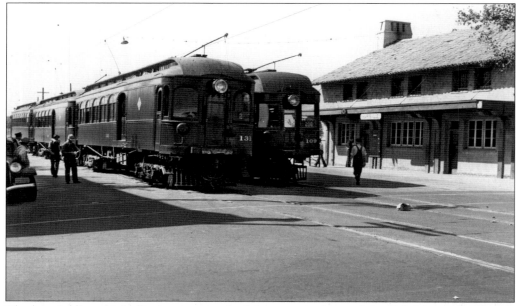

The late Addison H. Laflin Jr. photographed this meet in front of the SN's Marysville Station in October 1940. The shadows are ominous, for a year later SN passenger trains would be gone and these cars would be dismantled and burned at Mulberry. (Addison H. Laflin Jr. photograph, author's collection.)

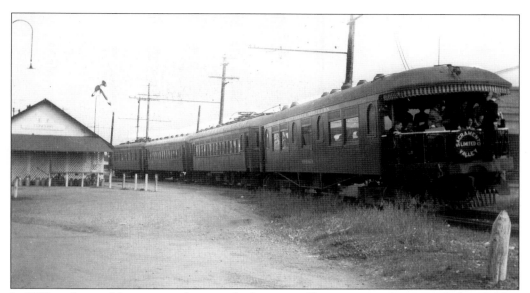

In 1939, parlor car *Moraga* is on the rear of a four-car railfan excursion charter at Concord. This segment of the SN later became part of the Bay Area Rapid Transit (BART), which now provides electric rail services, in part, where the interurbans used to run.

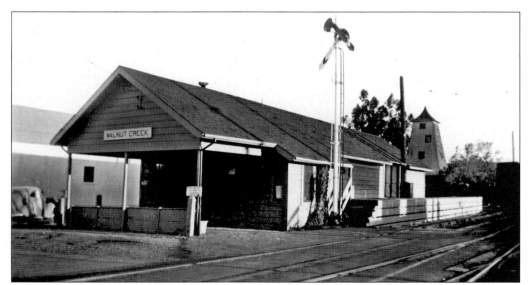

This was the OA&E, and later the SN, station at Walnut Creek. When built, this was wide open countryside; today it has been fully developed for suburban living and all that goes with it.

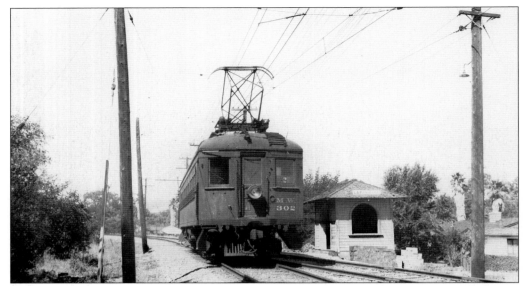

The SN stop at Lafayette in Contra Costa County would never be mistaken for Grand Central Station. The scene is 1947, and the SN is now gone, along with the pastoral setting. Only MW 302 survives, and it is in a museum.

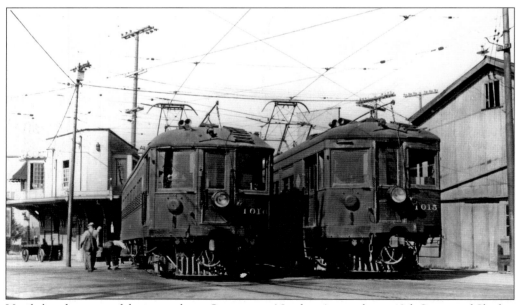

Until abandonment of the interurbans, Sacramento Northern's complex at 40th Street and Shafter Avenue in Oakland was always cramped for space, and a pair of big interurbans could take up a lot of room. The building at the left was the control tower.

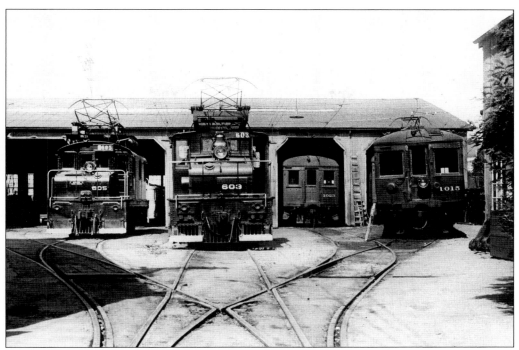

No less cramped for space were the SN's 40th and Shafter Shops. Viewed here, from left to right, are locomotives 605 and 603, Hall Scott 1023 and Cincinnati 1015, together with an economy of track work that allowed the complex to function. (Courtesy the late Stephen D. Maguire, author's collection.)

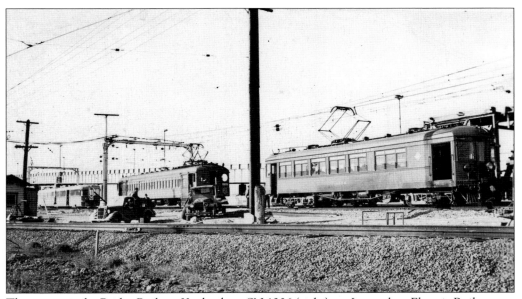

The setting is the Bridge Railway Yards where SN 1006 (right), an Interurban Electric Railway car on the Seventh Street line bound for Dutton Avenue (center), and a Key System train, bringing people to the World's Fair on Treasure Island (left), await their calls to duty.

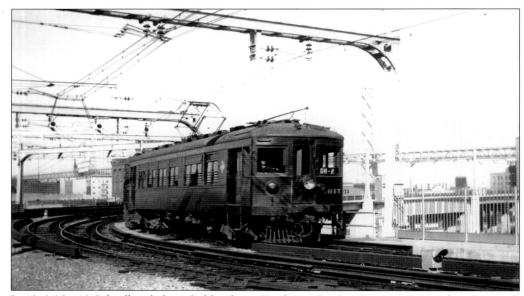

In 1940, No. 1017 deadheads from Oakland into Track No. 6 at San Francisco's Transbay Terminal. The Bridge Railway started two years after the bridge opened to automobiles. Because of declining patronage and rising automobile competition, the SN trains, dripping in red ink, were gone before Pearl Harbor. Had they continued into 1942, wartime rationing of tires and gasoline might have meant survival, another of history's "what ifs."

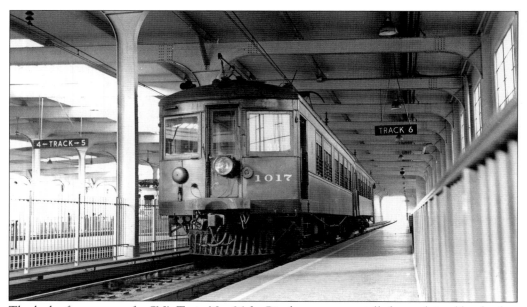

The lack of passengers for SN's Train No. 36 for Pittsburg may partially be explained by the fact that this was a Sunday and holiday local leaving San Francisco at 6:00 p.m. Be that as it may, the SN's management was already trying to abandon the money-losing interurbans.

Four

SACRAMENTO NORTHERN FREIGHT

Not all interurbans hauled freight, but those that did tended to last longer. The fact of the matter is that moving people, by whatever public conveyance one wishes to name, is invariably a money-losing proposition and needs a subsidy of one kind or another in order to survive.

That the Sacramento Northern interurban trains were subsidized by freight and express shipments is beyond dispute. Equally so from the historical perspective is that when the freight services could no longer cover passenger losses, the interurbans were doomed. When applications were made to the California State Railroad Commission for abandonment, permission was usually granted without fuss or bother, even in a highly regulated public utility state such as California.

Of the 10 California interurbans that could be called freight haulers, the average life beyond passenger service was 34 years; on the SN it was 35 years. Of those 10 interurban railways, the average lifespan overall was 57.6 years, while for the SN it was about seven decades.

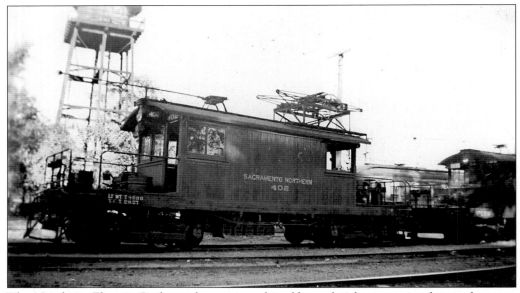

The Northern Electric Railway always viewed itself as a freight carrier and over the years built their own juice locomotives as well as purchasing them commercially. Among the former were Nos. 402–405. Made of all wood construction, they were quite light and yet lasted for 40 or more years.

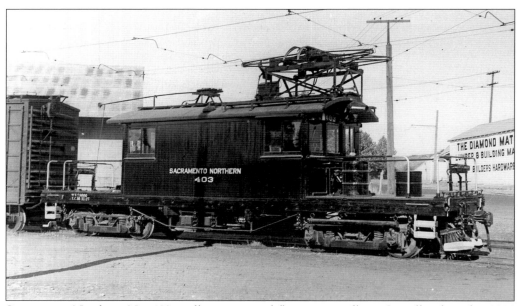

Sacramento Northern No. 403, really a motorized flat car, was idle in Oroville when this 1944 photograph was made. To prevent enemy aircraft from seeing a night train and using it for a target, No. 403 has a blackout hood over the headlight. After all, 1944 was wartime.

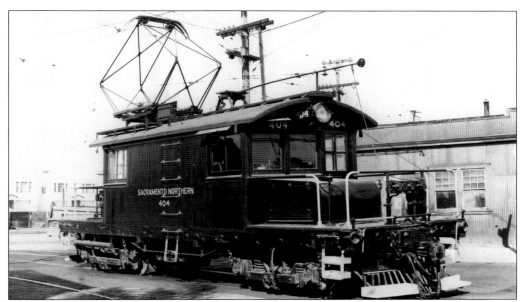

Compare this 1940 view of Sacramento Northern's 404 at Fortieth Street and Shafter Avenue in Oakland with the previous photograph of sister locomotive No. 403. The blackout hood on No. 404 has yet to be installed and the third rail shoes have been removed.

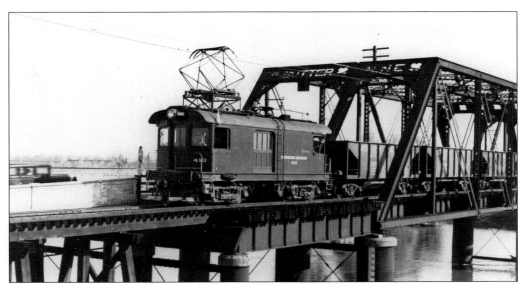

Sacramento Northern No. 410 crosses the Feather River Bridge into Sutter County in 1945 with a string of hopper cars that might be empties heading for the sugar beet fields. SN freights moved all kinds of agricultural products in California's rich Sacramento Valley.

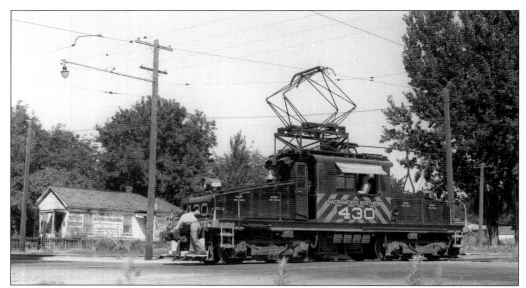

Sacramento Northern steeple cab No. 430 is shown in Sacramento in 1950. The brakeman is riding the footboards, a practice no longer allowed for what should be obvious reasons.

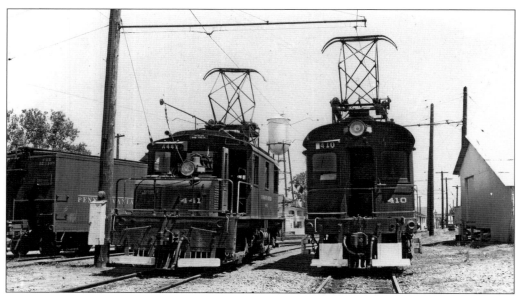

Juice hogs No. 441 (left) and No. 410 are at Mulberry in 1946. No. 441 was built by Baldwin-Westinghouse in 1920 for the SN and dismantled in 1954. In 1911, No. 410 was built at Mulberry as a combination box motor and locomotive No. 1010. In 1930, it was rebuilt as a locomotive, pure and simple, emerging as No. 410 and lasting until 1954.

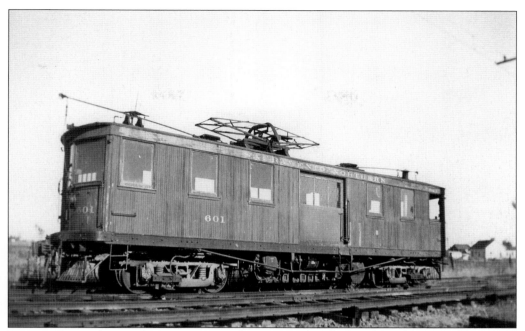

In interurban parlance, a box motor was as the name implies: looking like a boxcar and having its own motors and controls. It could run independently and was ideally suited for less than carload (lcl) freight, yet could also be used as a locomotive. SN 601 was such a car.

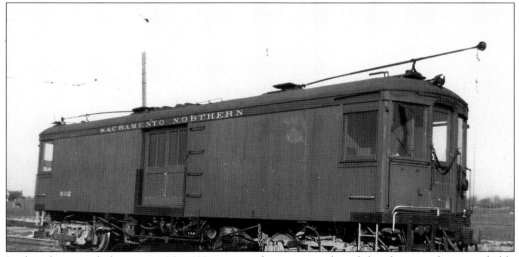

In this photograph, box motor No. 602 is minus the pantograph and the photograph was probably taken while leased to the Tidewater Southern during World War II. Note that all of the electrical equipment is underneath the body, allowing for more room inside for additional moneymaking lcl freight

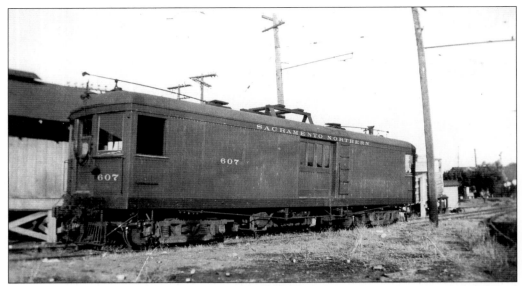

The third of the South End's box motors was No. 607, built by the shopmen at the 40th and Shafter Shops while another box motor was being dismantled. In September 1938, No. 607 was badly damaged by fire at Concord. No. 607 then went to Mulberry and storage until scrapping in 1941.

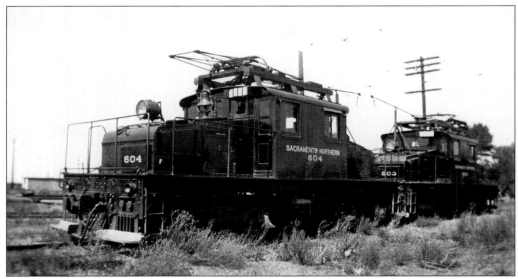

Locomotives No. 603 and 604 often worked together, either double-heading a heavy freight train or with one acting as a pusher at the back end of a freight train in the steep Oakland hills, which had up to a four-percent grade.

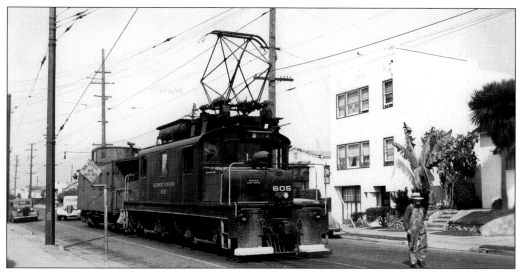

Because of the cramped conditions at 40th and Shafter, it is not unusual in old photos to see partially made up trains on Shafter Avenue. In this September 14, 1944, photograph, No. 605 and a caboose are on the Shafter Avenue track. The presence of the switchman probably means No. 605 is going back inside.

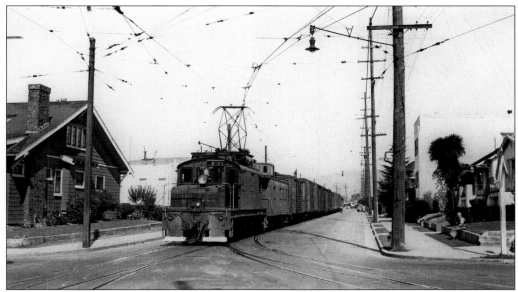

Sacramento Northern locomotive No. 605 is actually on the rear end of this freight on Shafter Avenue. Because of the steep ascent through the Oakland hills, SN freights were required to have a locomotive at both ends of the trains, not merely as pushers but for additional braking.

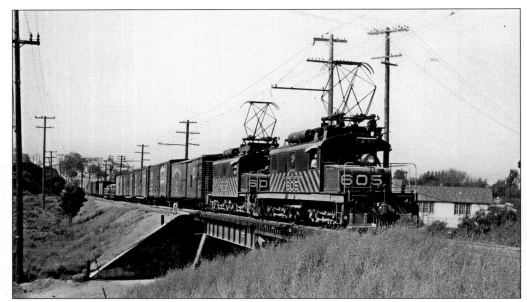

Juice hogs No. 605 and No. 606 were another pair of twins from Baldwin-Westinghouse, arriving on the OA&E in 1913. Intended for pulling passenger trailers, at 62 tons they were too heavy for the Key Pier. In 1957, both went off the roster together and were scrapped. This 1955 photograph was made at the Rockridge Bridge. (Tom Gray photograph, author's collection.)

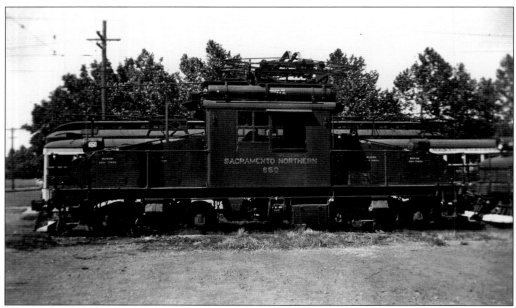

Sacramento Northern locomotives No. 650 and No. 651 from General Electric were alike in every way except that No. 650, seen here in Sacramento, weighed 60 tons while the sister weighed another half-ton more.

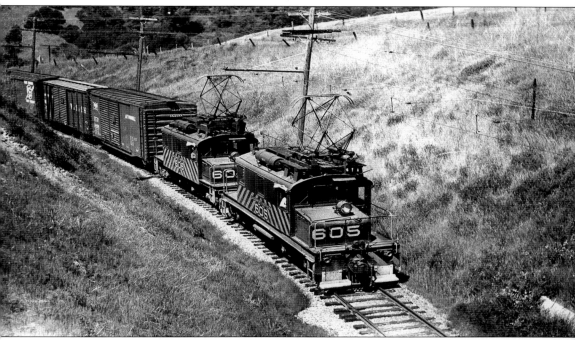

A railfan and photographer, Tom Gray took this picture of Sacramento Northern locomotives No. 605 and No. 606 doubleheading a freight through the curve at Valle Vista in 1955, long after the passenger interurbans had passed into history. Valle Vista, between Pinehurst and Moraga, was a magnificent setting for rail photography. (Tom Gray photograph, author's collection.)

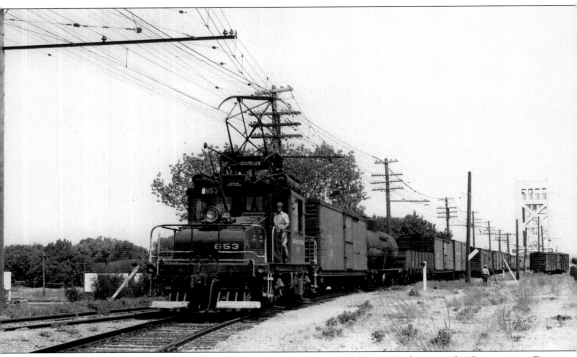

The year is 1939 and SN steeple cab No. 653 has just crossed Tower Bridge over the Sacramento River into Broderick. Built in 1928 for the Sacramento Northern Railroad by General Electric, No. 653, now at the Orange Empire Railroad Museum, was one of the last three SN electric locomotives.

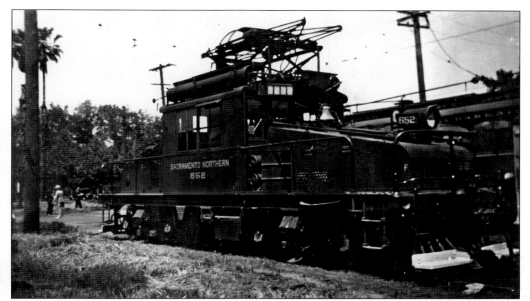

Steeple cab No. 652 was one of five locomotives in the 650 class that were the SN's first to be able to operate on either 600 or 1,200 volts. This gave them the flexibility to operate on either the North or South Ends. Today No. 652 is at the Western Railway Museum.

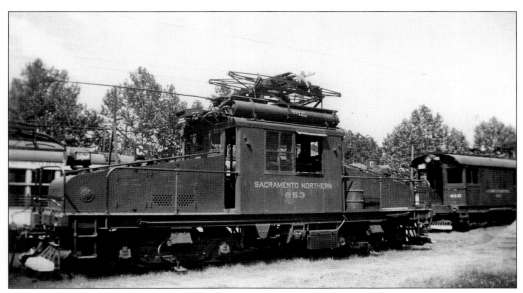

Sacramento Northern locomotive No. 653 was one of the last three juice hogs left on the roster, performing duties at Marysville until the end of SN electrification. Today No. 653 is active at the Orange Empire Railroad Museum in Perris, California. At right is locomotive No. 410.

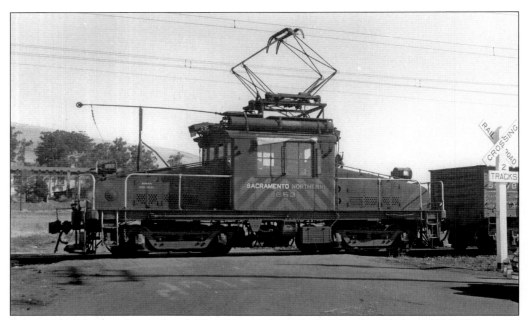

Sacramento Northern's steeple cab No. 653 is working the head end at Clyde in 1956. The steeple cab, being double-ended, was very versatile and the use of the pantograph rather than trolley poles meant the locomotive could go in either direction at a signal's notice without having to raise or lower trolley poles. Today No. 653 is at the Orange Empire Railroad Museum.

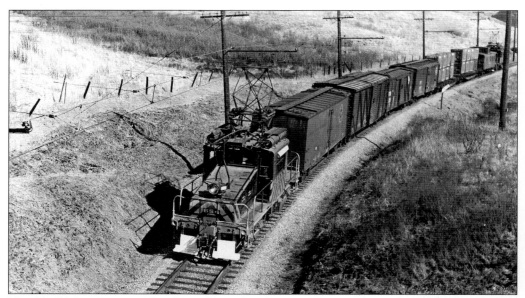

No. 654 leads a seven-car freight and a pusher locomotive around a curve near Valle Vista in 1949. During World War II and the Korean War, business was good on the SN as parent Western Pacific used the SN for freight to the Oakland Army Base, the Concord Naval Weapons Station, and the steel mills of Pittsburg, California.

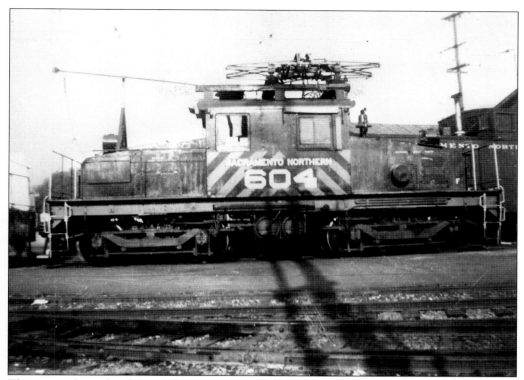

This particular style of electric locomotive was called a steeple cab, and the sloping hoods gave the motorman greater visibility. The spring-mounted trolley pole contacted with the overhead wire, providing power to run the air compressor, after which the pneumatic pantograph was raised and the pole lowered.

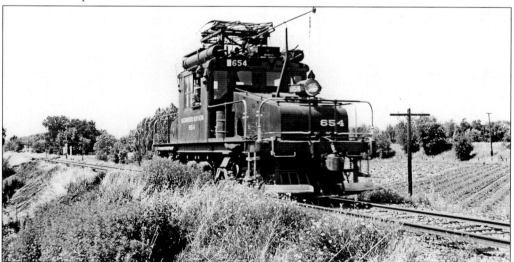

In 1940, No. 654 was photographed working on the SN's Woodland Branch. The pantograph is down, a clear indicator of the presence of the electrified third rail, partially obscured by weeds. No. 654 resides today at the Western Railway Museum in Solano County, and the Woodland Branch is now the Sacramento River Train, hauling freight and tourists.

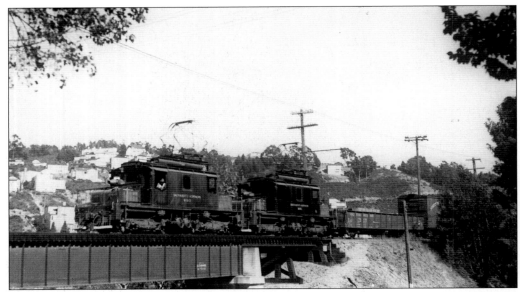

At 68.5 tons, Nos. 660 and 661 were the SN's second heaviest electric locomotives. Here they are doubleheaded to pull freight through the Oakland hills with those four-percent grades. This picture was taken in 1944 at the bridge over Thornhill Drive in Oakland's Montclair district.

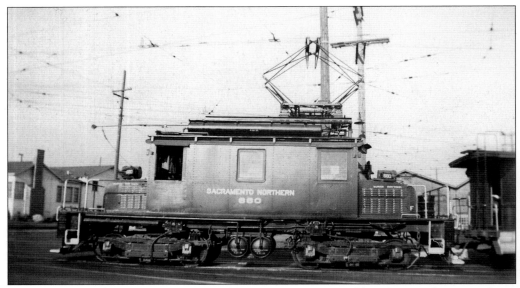

Built in 1927, No. 660, pictured here, and mate No. 661 were Baldwin-Westinghouse products. They were equipped to operate on either 600 or 1,200 volts, with pole or pantograph, third rail, or overhead wire.

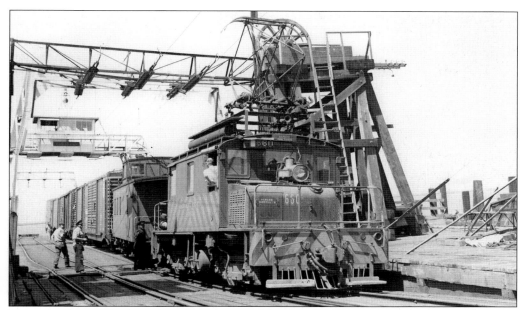

The Sacramento Northern ferry *Ramon* carried freight as well as passenger trains. As shown in this 1949 photograph taken at Mallard, No. 660 is pushing a cut of freight cars onto the vessel from the apron that is designed to give a perfect meet of tracks, regardless of the tides.

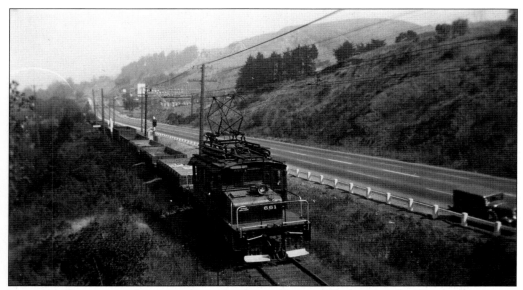

No. 661 pulls a string of empties alongside what will eventually become the Warren Freeway in Oakland. During the days of the passenger interurbans, the men who operated SN equipment were called motormen. After 1941 they preferred to be called engineers.

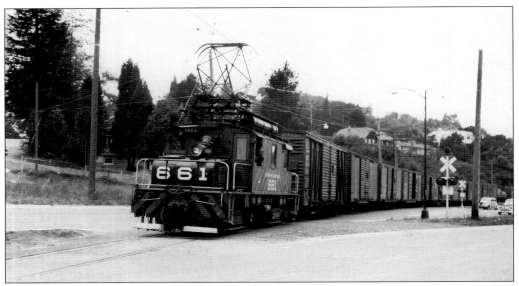

In 1949, juice hog No. 610 is pictured pulling a freight train through the Rockridge area of Oakland, crossing Moraga Avenue. The vintage boxcar in back of No. 661 is outside-braced, providing a flush interior bulkhead.

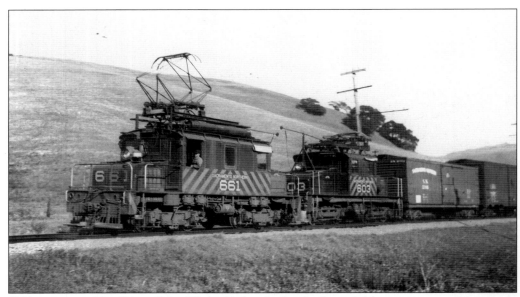

SN locomotives No. 601 and No. 603 double-head a freight through Moraga, once a cattle-grazing area. This photograph was made in 1948 as forces such as the GI Bill (with guaranteed home loans for World War II veterans stimulating home construction), federally funded highways, and the San Francisco-Oakland Bay Bridge were converging to alter the landscape into a suburbia.

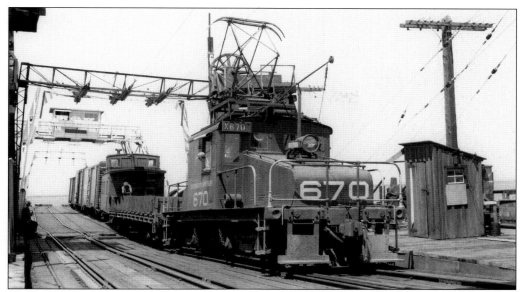

The *Ramon* was strictly for SN trains, passenger or freight. There were three tracks on the main deck, with full operating trolley wires above. At Mallard in 1949, No. 670 is doing the grunt work of hostling the train. Freight locomotives usually didn't ride the *Ramon*.

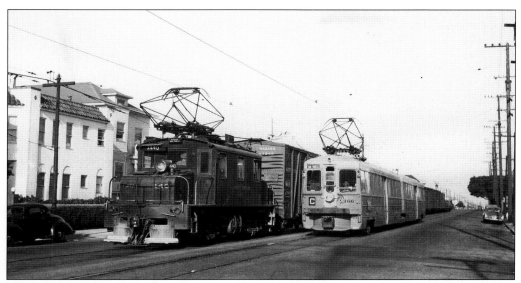

Since the Key System's rails were heavy enough and the overhead wiring was in place, it made sense for the Key System to engage in a lively freight-switching business, connecting with the Sacramento Northern at Fortieth Street and Shafter Avenue, and over the Key's Fortieth Street rails where SN No. 440, leased to the Key System, passes by the Key's No. 166, headed for San Francisco. (Tom Gray photograph, author's collection.)

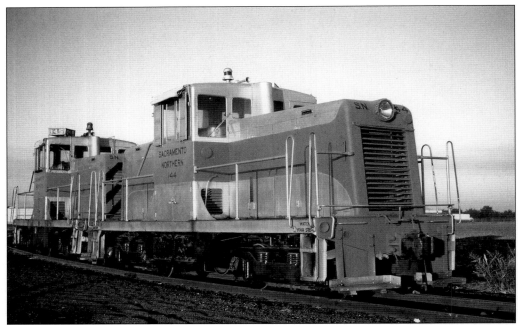

The 1942 Diesel Firemen's Case versus Western Association of Railway Executives held that diesel-electric locomotives having a 44-ton rating were comparable to juice locomotives and didn't require a fireman. In 1945, the California Railroad Commission outlawed third-rail operations, and in May 1946 the SN bought five 44-ton locomotives, including Nos. 144 and 145, shown here. (Steve Graves photograph.)

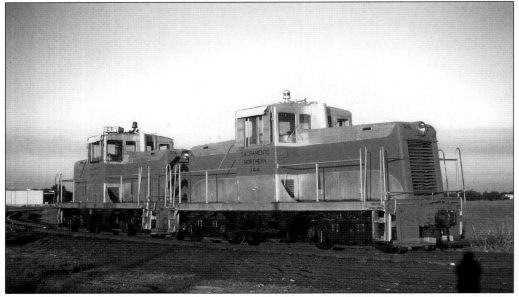

Two of the five 44-ton locomotives that came to the SN on May 24, 1946, are parked on Western Pacific rails in Stockton, California, in August of 1971, having been sold to Chrome Crankshaft the month before. When new, they cost the SN $12,514 each, and were referred to by the crews as "mice."(Steve Graves photograph.)

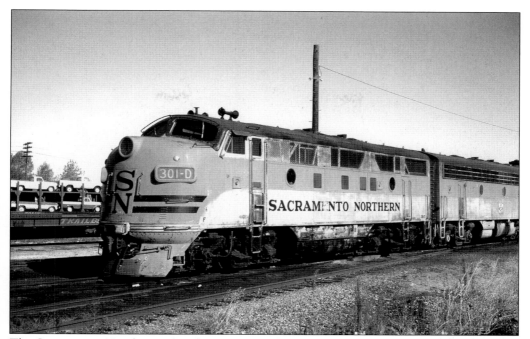

The Sacramento Northern's diesels were painted in the same style as their parent company, Western Pacific. Seen here in Oroville in July 1971 is No. 301 D, which had been retired since May of that year. (Steve Graves photograph.)

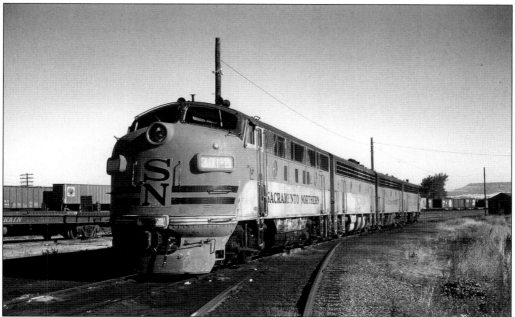

The scene is Oroville in July 1971 as EMD FA3 Nos. 301 D and 301 A, which came from the New York, Ontario, & Western in 1957, are sandwiching a brace of Western Pacific B units. For six years the SN's electrics had been gone, and these two "covered wagons" had been in retirement for two months. (Steve Graves photograph.)

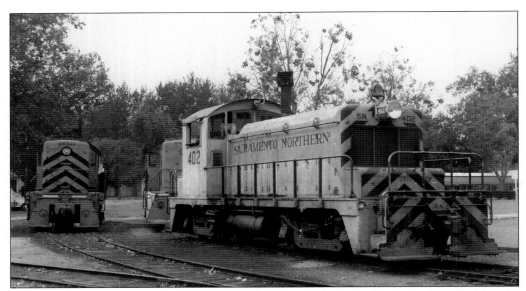

The post-World War II years brought diesel-electric locomotives to the SN, setting the stage for the SN's eventual demise. Diesels were not restricted to overhead wires, allowing for exchanges of track rights with other railroads. Here a trio of EMC SW-1's lay over in Sacramento where the electrics once reigned.

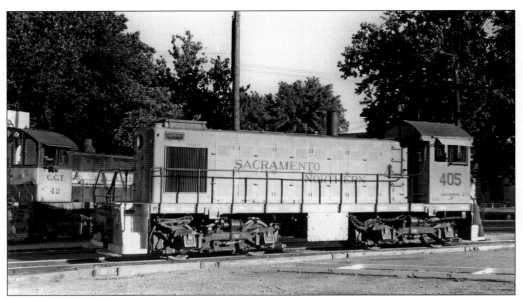

In 1970, SN No. 405 was photographed in Sacramento alongside Central California Traction Company No. 42. The Traction Company was another California interurban, running between Sacramento and Stockton, which became a dieselized, freight-only railroad.

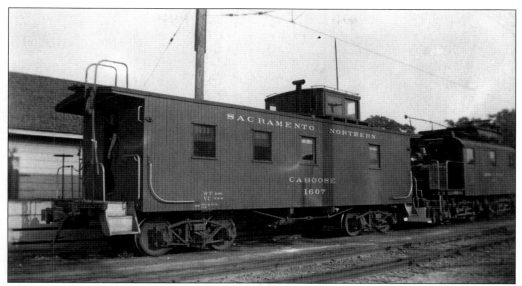

The rear end of every freight train used to have a caboose coupled to it. The caboose was the train's office, the domain of the conductor and rear brakeman. Technology has replaced the brakeman, the conductor rides in the locomotive, and written train orders have been replaced by electronic communications.

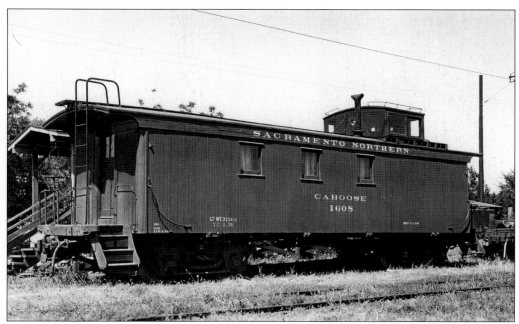

Cabooses were called a number of names by railroaders, including "bobbers," "crummies," "shacks," "cabins," and other slang names, sometimes with unprintable adjectives. There was no glamour in them because of their bounce and danger from rear-end collisions. Photographed on December 1, 1940, was No. 1608 in Yuba City.

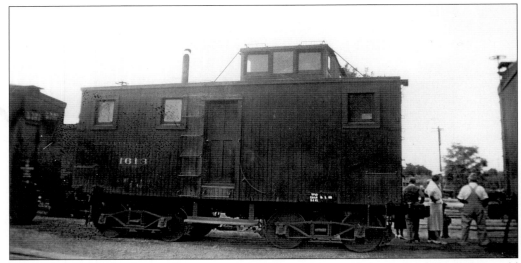

The Sacramento Northern cabooses came in different sizes and shapes, and No. 1613 would appear to have been from a toy train set except for the appearance of the workmen at the right in this picture.

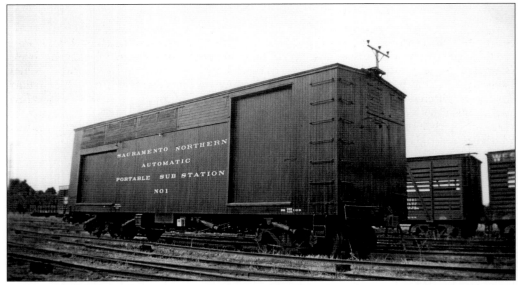

Among the SN's lesser-known cars were the portable substations that were used to provide extra power for the additional trains needed during harvest times in the Sacramento Valley's rich agricultural regions. No. 1, pictured here, is still in use at the Western Railway Museum.

Five

RELATED RAILWAYS

Just as no man is an island, no railroad could be called an island of the high iron when it interchanged freight with three transcontinental railroads (Western Pacific; Atcheson, Topeka & Santa Fe; and Southern Pacific) as well as such short lines as Central California Traction Company; Oakland Terminal Railroad; and, albeit indirectly, Tidewater Southern. While volumes have been written about the transcontinental lines, not enough has been written about the others, such as the Tidewater Southern or the Oakland Terminal.

It is right, therefore, that at least a brief glimpse be taken of some of those companies with which the SN had a working relationship on a regular basis in one way or another.

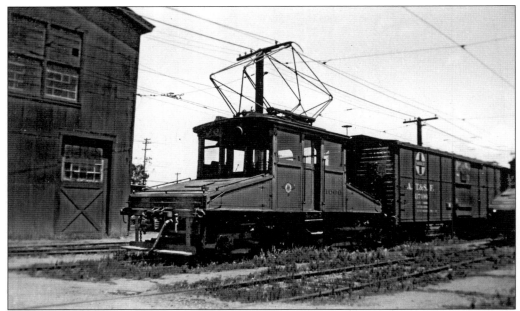

After August 1936, the Key System's freight switching business in Oakland and Emeryville was called Oakland Terminal Railroad Company, using a steam locomotive and two steeple cabs. One of the first juice hogs in the West, the No. 1000 is shown here pulling Santa Fe boxcar No. 117496. It was built around 1895 and scrapped by the Key System in 1947.

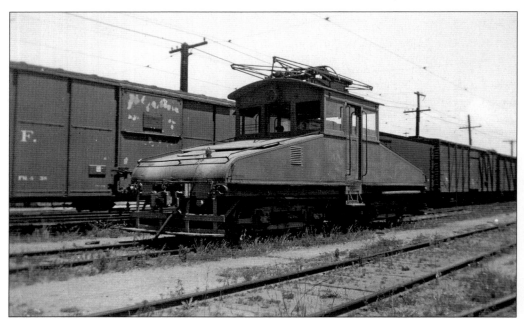

Steeple cab No. 1001 was also used by the Oakland Terminal and was a frequent visitor to 40th and Shafter. When the OTRR was sold in 1943 to the Western Pacific and the Santa Fe, the Key System kept Nos. 1000 and 1001 for its own uses. Until electric operations ended on May 1, 1955, the OTRR leased SN locomotives No. 440 and No. 442.

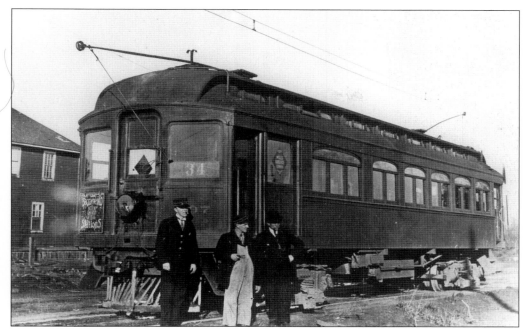

Traction Company employees pose next to the Central California Traction Company (CCT) No. 203 in Stockton around 1910. The car is Sacramento-bound to meet with the NE. The wing collard conductor is smoking a cigar while the overalled motorman is puffing his pipe, as is the gentleman at the right; all on company time, too. How times have changed.

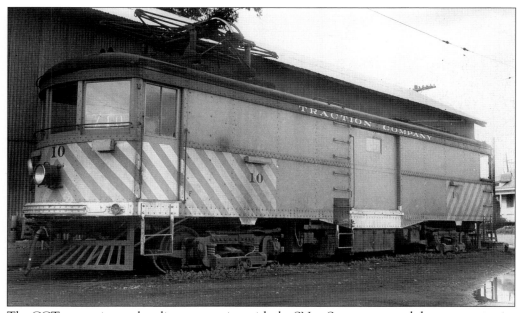

The CCT was an interurban line connecting with the SN at Sacramento and the two companies always had a good relationship. The Traction Company preferred box motors as locomotives, such as No. 10 in Sacramento in 1946. CCT box motor No. 7, fully restored, does similar chores today at the Western Railway Museum.

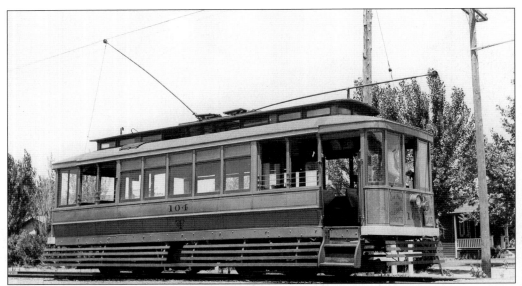

The Central California Traction Company provided a local streetcar line in Sacramento from downtown to a real estate development called Colonial Heights. Service began on May 11, 1910, and continued until 1943 under CCT ownership. Pictured here at Colonial heights, No. 104 was built in 1906 for CCT's Stockton lines.

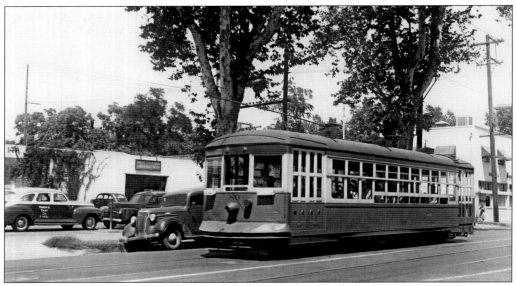

CCT's Sacramento streetcars ran on Eighth Street from K to X Street, X Street to Thirty-first Street (now Alhambra Boulevard), and on to Sacramento Boulevard (now Broadway), Second Avenue, Stockton Boulevard, and along Twenty-first Avenue to St. Mary's Cemetery. In 1942, fully enclosed, No. 89 has all of its windows open—it must be summer. No. 89 was built in 1905 for Fresno Traction Company and was bought in May 1939 for Sacramento service.

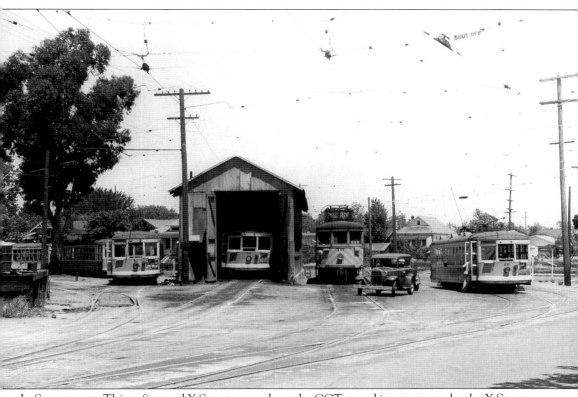

In Sacramento, Thirty-first and X Streets was where the CCT stored its streetcars, by the X Street rails shared by the CCT and the SN. The year is 1939, and within the next decade all of this will change and streetcars and interurbans will be gone from the capital city's streets.

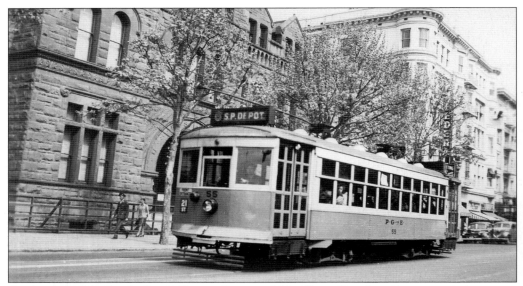

On April 14, 1943, Pacific Gas & Electric Company's No. 55 rumbles along Sacramento's downtown streets while en route to the Southern Pacific depot.

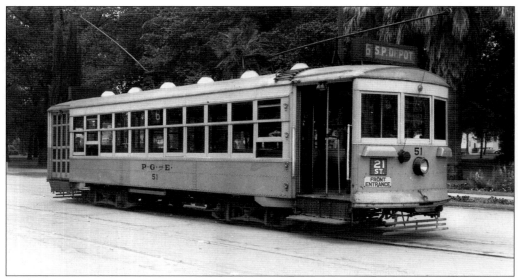

In this 1940 view, Pacific Gas & Electric (PG&E) No. 51 is at the end of the No. 6 line connecting McClatchy Park with the Southern Pacific depot, 4.42 miles across town. A federal law forcing utility companies to divest themselves of streetcar ownerships hastened the demise of Sacramento's streetcars.

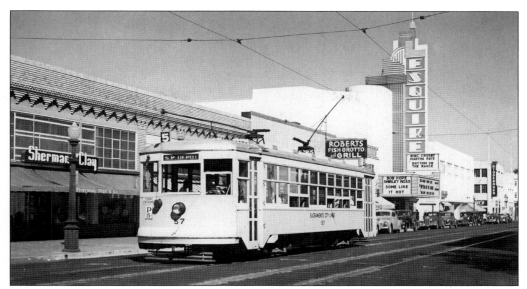

Sacramento City Lines was part of a national consortium that, in 1946, converted Sacramento's streetcars to buses. Streetcar patronage had been declining for a number of years and there actually was a time when buses were considered to be the answer to aging and money-losing streetcars.

Two PG&E streetcars are in front of the Southern Pacific depot, waiting to begin their next runs. This 1944 photograph was made just after the takeover of Sacramento's streetcars by Sacramento City Lines, a subsidiary of National City Lines. During 1946–1947, SCL would convert all Sacramento streetcars into bus lines.

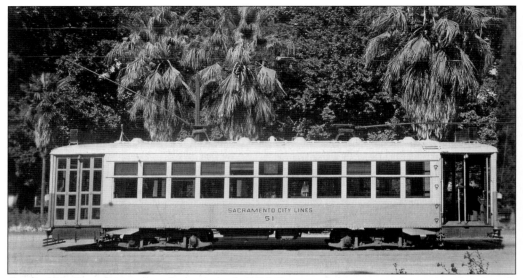

Again, No. 51 is shown, but this time with PG&E painted out on its sides and replaced with the lettering "Sacramento City Lines." In fact, it was the only outward change ever made to Sacramento's streetcars until they were replaced with buses.

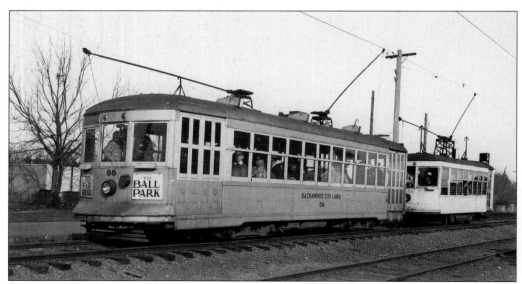

This photograph was taken in 1945 as SCL No. 88 (ex-PG&E 88) and SCL No. 70 (ex-SN 70 and ex-San Jose Railroads 141) were nearing their end. Poor old No. 70 by now was reduced to line-greasing duties; hence the unkempt appearance. This photograph was taken during a railfan excursion.

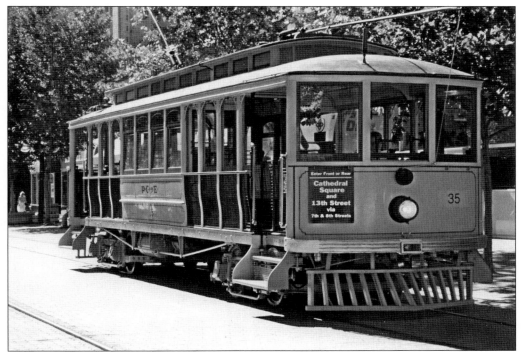

A former PG&E streetcar rolls in Sacramento during Railfair 1991. It was loaned to the city for Railfair, with its number 35 restored, and now resides permanently in Sacramento. It had been in private ownership before being restored by volunteers of the San Jose Trolley Corporation to run in San Jose with other historical cars. (Paul C. Trimble photograph.)

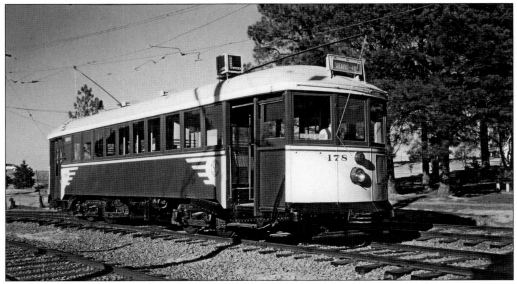

San Francisco MUNI streetcar No. 178 also has a SN connection. Purchased by the Bay Area Electric Railroad Association in 1959, the car made the ceremonial "Last Run" between Marysville and Yuba City on May 5 of that year. Now residing at the Western Railway Museum, car No. 178 runs for visitors to ride. (Paul C. Trimble photograph.)

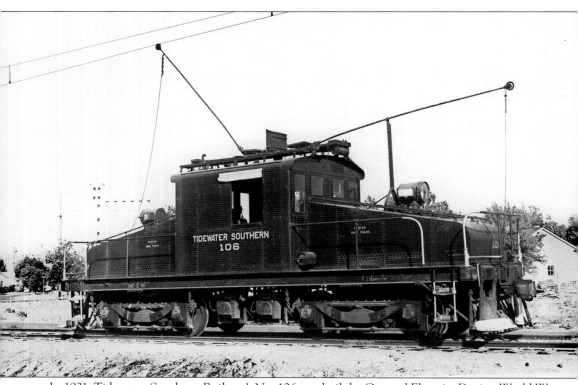

In 1921, Tidewater Southern Railway's No. 106 was built by General Electric. During World War II, the steeple cab was leased to the SN in exchange for SN box motors No. 601 and No. 602. In 1948, the SN purchased the locomotive for $13,850, becoming SN No. 670. In 1956, No. 670 was scrapped.

Six

THE SACRAMENTO NORTHERN LIVES!

It is logical that today's transit lines often follow the rails of yore: the wagon roads followed the original foot trails, the railroads often followed the wagon trails, and all over the country roads and highways parallel or follow the old railroad tracks that established with a degree of permanence today's transportations patterns. Today some services of the Bay Area Rapid Transit District (BART) attempt to emulate those electric railways of which BART is simply the latest version. In the same vein, the SN's small suburban streetcar line between Sacramento and Swanston has been resurrected by Sacramento's RT Metro light rail line. The Woodland Branch of the SN has been preserved and is now the Sacramento River Train, an 18-mile-long tourist and freight railroad from Woodland to West Sacramento. It is owned by the Sierra Railroad, an experienced operator of preserved railways.

Rolling stock from the Sacramento Northern is preserved by four California rail museums: the California State Railroad Museum in Sacramento, the Portola Railroad Museum in Portola, the Orange Empire Railroad Museum in Perris, and the Western Railway Museum in Solano County. The latter not only owns the lion's share of preserved equipment, but since 1993 has owned over 22 miles on SN tracks. In truth, the Sacramento Northern lives!

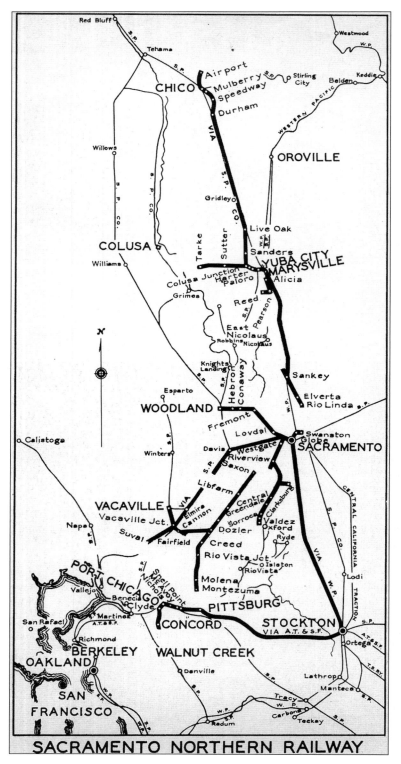

With conversion from electric to diesel, the SN was able to exchange trackage rights with other railroads and abandon redundant tracks. This map shows the SN breaking up and utilizing other railroads' rails, although there would be more to come. The service to Swanston is now a Sacramento light rail line, the service between Concord and Pittsburg is now a rapid transit line, the Woodland Branch is a tourist railroad, and the Montezuma-Dozier-Cannon tracks are part of a rail museum.

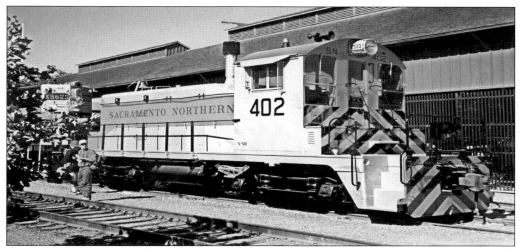

Among the collections of Sacramento Northern rolling stock that have been preserved at railroad museums is the EMD-built SW-1, SN No. 402, pictured here at the California State Railroad Museum in Sacramento. (Paul C. Trimble photograph.)

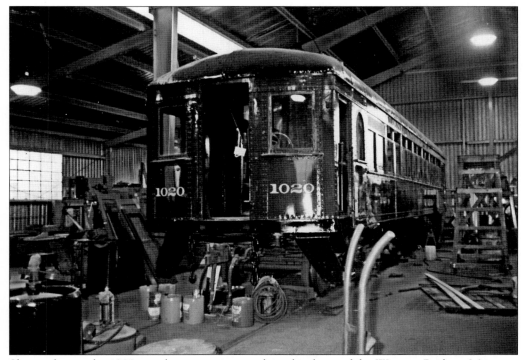

Shown during the 1990s on the restoration track in the shops of the Western Railway Museum, SN No. 1020 is undergoing a full restoration as Oakland, Antioch, & Eastern Railway No. 1020. Today the car is in active service at the Museum. (Paul C. Trimble photograph.)

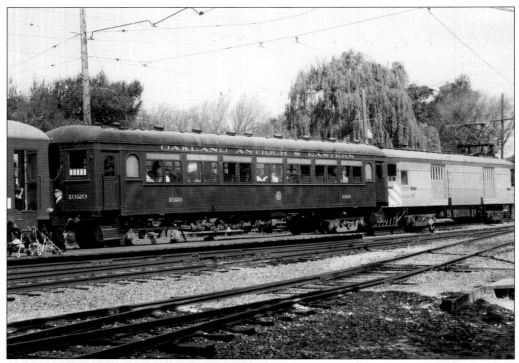

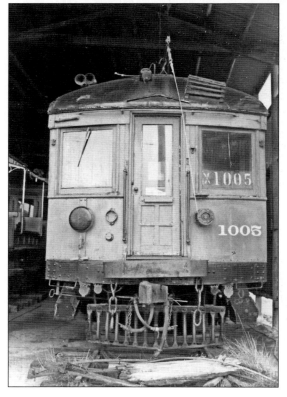

Headed by Central California Traction box motor No. 7, a three-car consist, which includes OA&E No. 1020 and Salt Lake & Utah No. 751, helps keep the spirit of interurban railroading alive at the Western Railway Museum. (Paul C. Trimble photograph.)

Far away from the car houses at either 40th and Shafter or Mulberry, Sacramento Northern combo No. 1005 awaits the next call to duty in Carhouse No. 1 at the Western Railway Museum prior to going into the shops for restoration. (Paul C. Trimble photograph.)

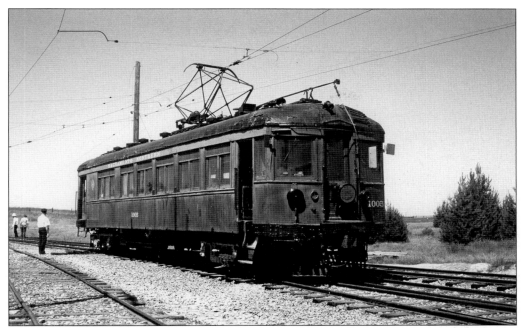

Venerable Sacramento Northern No. 1005 poses in June 1975 for the camera of railfan Steve Graves at the California Railway Museum, later called the Western Railway Museum, near the interchange between the Museum and SN rails. (Steve Graves photograph.)

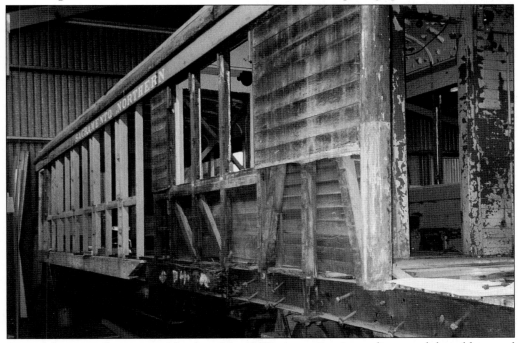

As work began on Sacramento Northern No. 1005's restoration, it was discovered that old age and a badly bent underframe from a collision many years before had left more damage than originally estimated. (Paul C. Trimble photograph.)

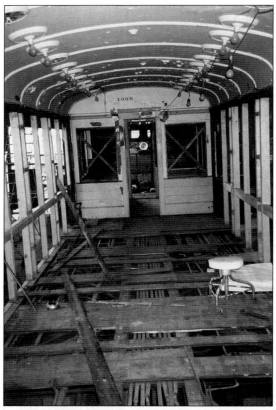

The interior of SN No. 1005 also required plenty of work. The car was built in 1913 and had seen better days. Moreover, the Key System had made some modifications. As of this writing, the car is being restored to its OA&E appearance. (Paul C. Trimble photograph.)

The roof of No. 1005 did not need rebuilding, although there was plenty of room for repairs. When fully restored and outshopped, it is expected that the car will be as good as new. (Paul C. Trimble photograph.)

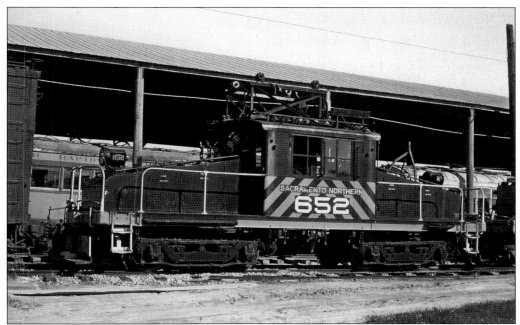

Sacramento Northern No. 652 spent its last years in Marysville being "cannibalized" to provide spare parts for by then obsolete sisters No. 653 and No. 654. Today Nos. 652 and 654 call the Western Railway Museum home while No. 653 resides at the Orange Empire Railroad Museum in Perris, California. (Steve Graves photograph.)

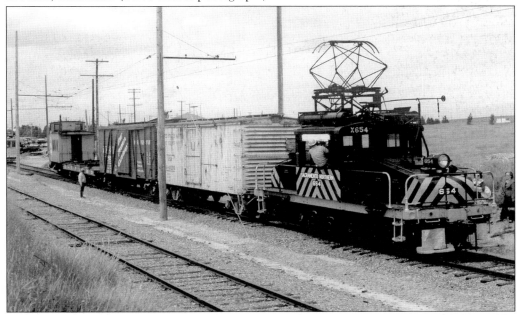

In May 1979, a mock freight train at the Western Railway Museum consisting of SN No. 654, U.S. Navy boxcar No. 61-00200, Minneapolis & St. Louis boxcar No. 28124, a flatcar, and Great Northern Railway caboose No. 443 gave visitors an idea of interurban freight operations. (Steve Graves photograph.)

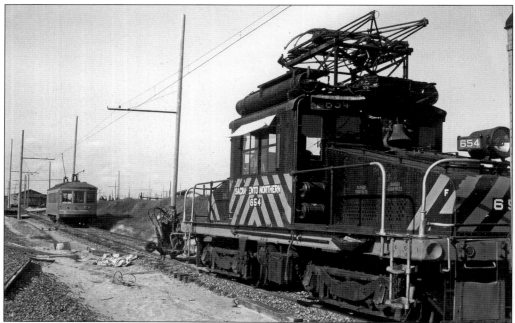

Indiana Railroad No. 202 stops short of SN No. 654 at the Western Railway Museum in April 1973, two decades before the Bay Area Electric Railroad Association acquired title to the SN's Montezuma Division, just a few feet to the left of where this photograph was taken. (Steve Graves photograph.)

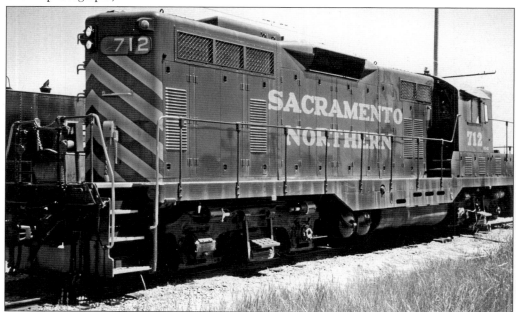

Sacramento Northern diesel-electric locomotive No. 712 rests quietly on her home rails at the Western Railway Museum. Since this photograph was taken, No. 712, a 1953 EMD GP7 workhorse, has been transferred to the Portola Railroad Museum in Portola, California. (Paul C. Trimble photograph.)

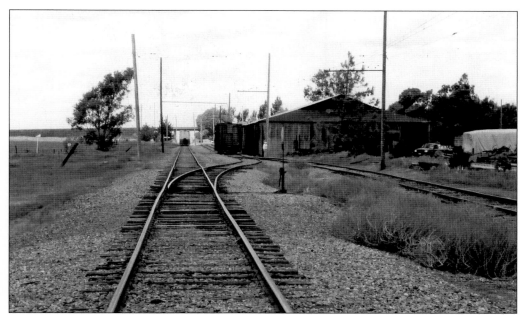

Central California Traction boxcar No. 301 is parked next to the Blakemore Barn at Rio Vista Junction, a scene reminiscent of those long ago days when the barn stored grain and other cargo to be loaded aboard SN freight trains. This is all part of the Western Railway Museum today. (Paul C. Trimble photograph.)

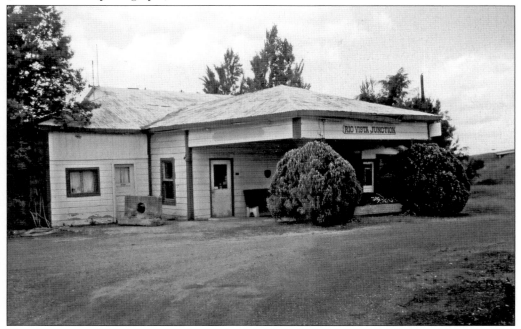

This former wooden gas station is located at Rio Vista Junction at State Highway 12 on the SN. The interurbans stopped here and passengers walked to the gas station to board a Rio Vista Transit Company auto stage for Rio Vista or Isleton. For many years, this was the Western Railway Museum's entrance and bookstore. (Paul C. Trimble photograph.)

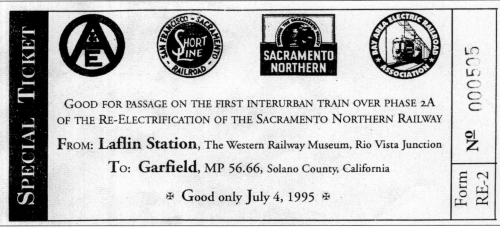

As the Western Railway Museum's volunteers rehab the SN rails and restore the overhead trolley wire, special trips commemorate each advance. Garfield, at Milepost 56.66, is where Little Honker Bay Road crosses the SN's high iron.

Historic Old Shiloh Church, built in 1876, is another bit of Golden State history that can be seen from the windows of the Western Railway Museum's interurbans while traveling over the rails of the Sacramento Northern in Solano County.

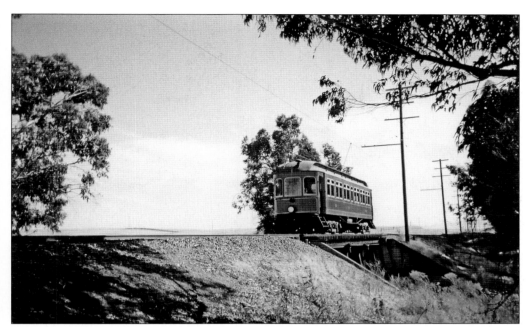

Peninsular Railway No. 52 is but one of the interurban cars that travel today over the SN rails as part of the Western Railway Museum. The car was built in 1903, the railway in 1913, and the scenery is timeless. (Don Meehan photograph, author's collection.)

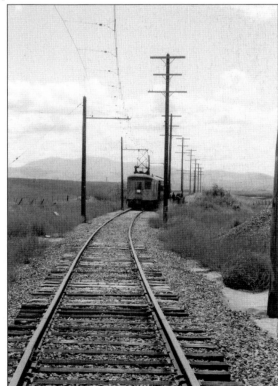

Thanks to the efforts of the volunteer members of the Bay Area Electric Association, this segment of the SN looks much as it did when interurbans and freights rolled on these rails. Poles have been mounted and the overhead has been hung according to SN specifications. (Paul C. Trimble photograph.)

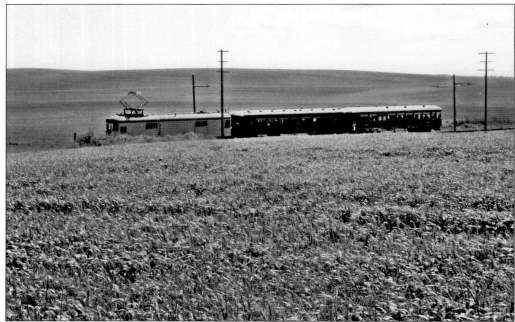

The Montezuma Hills south of the Western Railway Museum is grassland used primarily for grazing livestock. Occasionally, a section is harvested for hay, wheat, or barley. Most of the land is clay with a thin topsoil, and not favorable for deep-root farming. (Paul C. Trimble photograph.)

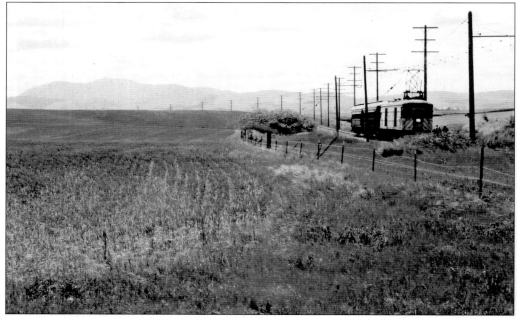

Looking south, Solano County grasslands slope gradually down to the Sacramento-San Joaquin Rivers delta and Suisun Bay in this springtime view of the Sacramento Northern Railway. Today a train is heading back to the Western Railway Museum, about four miles away. (Paul C. Trimble photograph.)

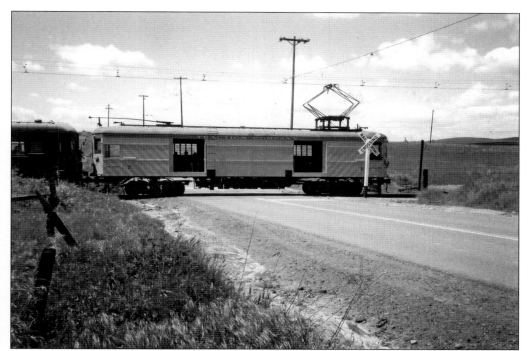

A country road located miles from the nearest town, an old fence, and an interurban railway may look like something from the 1930s, but it is actually an April 2005 view as CCT box motor No. 7 crosses Shiloh road on the SN in Solano County. (Paul C. Trimble photograph.)

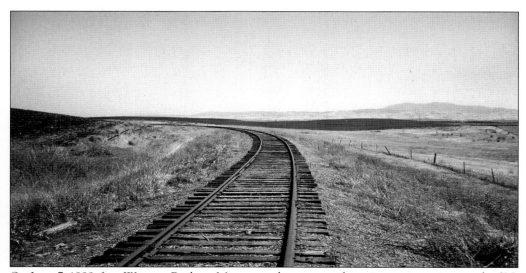

On June 7, 1999, four Western Railway Museum volunteers made an inspection trip over the SN, south from Rio Vista Junction. Looking south from below Shiloh Road, the SN veers to the east. Mount Diablo is in the background at the right. (Paul C. Trimble photograph.)

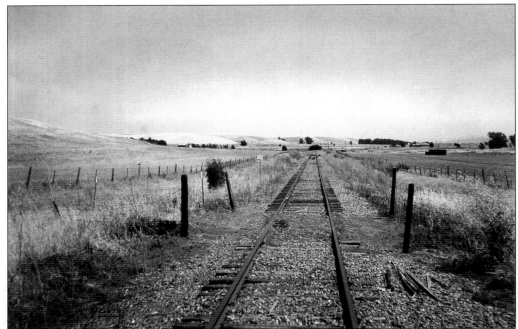

In this view, taken while looking south from Milepost 53, the rusty but serviceable rails remain. However, there is little trace of the electrification that once made this an interurban railway. (Paul C. Trimble photograph.)

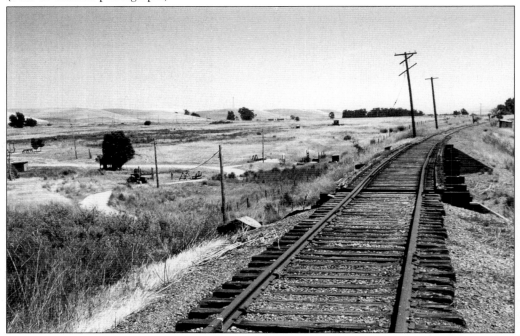

Between Milepost 53 and Molena, the SN's track is on a high railbed in order to keep the track as level as possible and avoid any grades. This is the site of a rod and gun club near Birds Landing. (Paul C. Trimble photograph.)

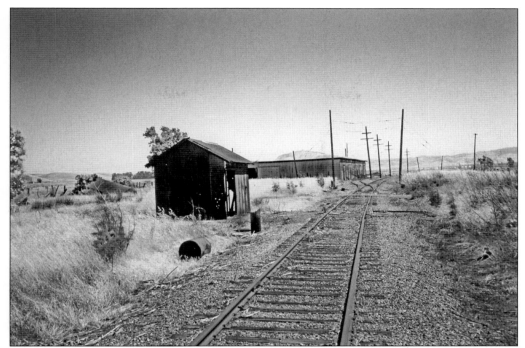

At Molena, an ancient grain shed and siding, together with a few remaining trolley wire poles, serve as a reminder that before the days of paved roads and highways, the Sacramento Northern Railway was a vital transportation artery in Solano County. (Paul C. Trimble photograph.)

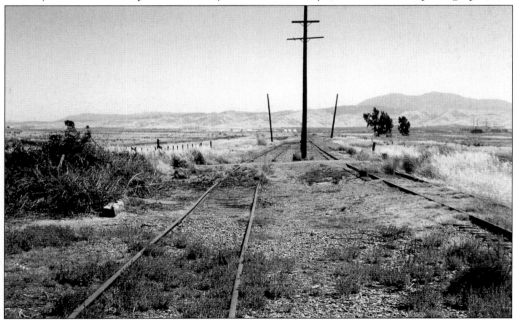

Looking south from Molena siding, three trolley wire poles stand as silent sentinels from the past in a sweeping landscape north of where the Sacramento and San Joaquin Rivers separate Solano County from Contra Costa County. (Paul C. Trimble photograph.)

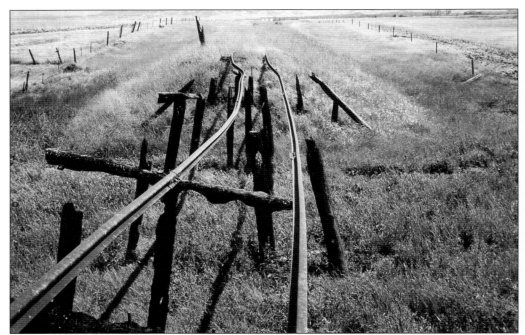

Farther south from Molena, the remnants of a burned-out trestle leave the rails literally in a state of suspension, waiting for the day when this part of the railway will be rebuilt and electrified for the benefit of visitors to the Western Railway Museum. (Paul C. Trimble photograph.)

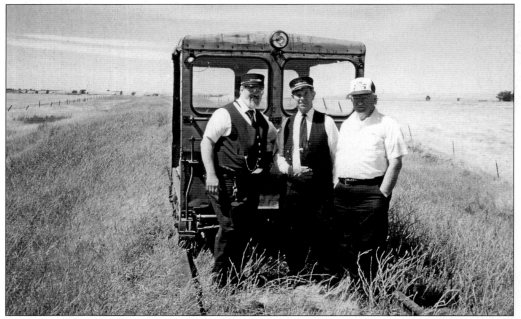

Dreaming of when the Western Railway Museum will be able to operate restored interurbans all the way south to Montezuma are, from left to right, Paul C. Trimble, Gerald C. Graham, and Raymond Muther. Behind the camera was Robert Murphy. (Robert Murphy photograph, author's collection.)

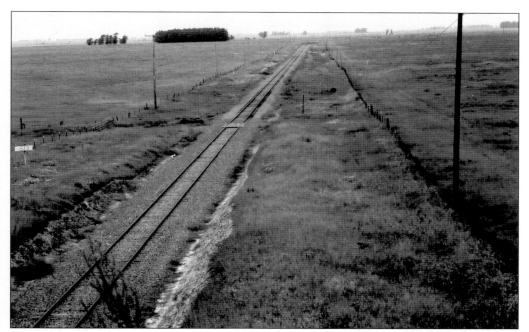

Looking north from State Highway 12 and what was once called Rio Vista Junction, there is a scene as pastoral as it was in 1913 when these rails went to Sacramento. Today the overhead wire is gone and the rails are part of the Western Railway Museum. (Paul C. Trimble photograph.)

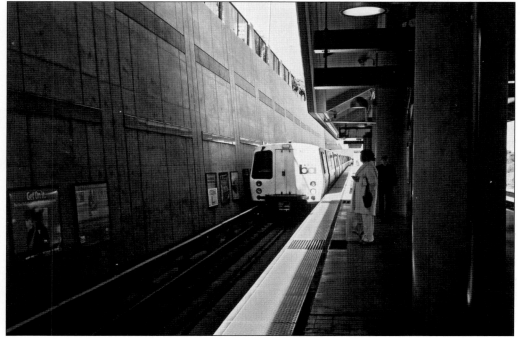

A modern BART train rolls into North Concord Station from Pittsburg/Bay Point, virtually duplicating with rapid transit cars what was once offered by the Sacramento Northern Railway's interurbans seven decades ago. (Paul C. Trimble photograph.)

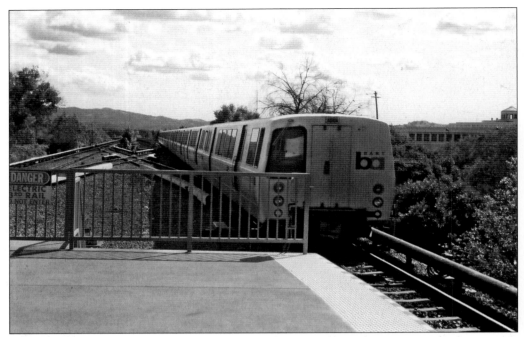

A 10-car BART train leaves Concord Station for Pleasant Hill on what was once the Sacramento Northern right-of-way. This was used as test tracks during the planning and testing period for BART. (Paul C. Trimble photograph.)

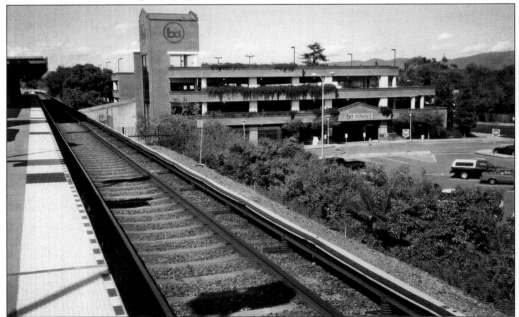

This modern suburban rapid transit station, complete with a parking lot for automobiles, is located north of the loading platform. While voltages and track gauges differ, it's important to remember that BART is actually the second electric railway using this real estate. (Paul C. Trimble photograph.)

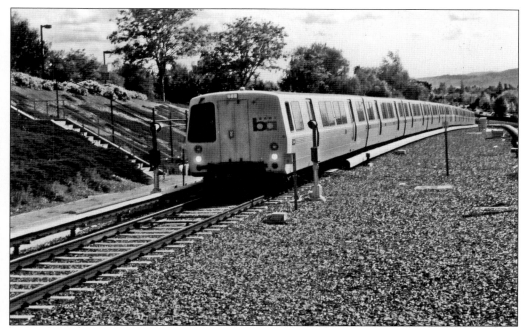

A far cry from the San Francisco–built Holman cars or those from Hall Scott in Berkeley, these "C" model BART cars are from Alsthom-Atlantique, were made in France, and are riding on the former Sacramento Northern right-of-way in Concord. (Paul C. Trimble photograph.)

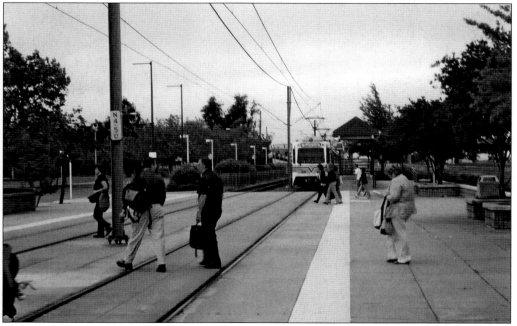

The SN's Elverta Scoots have been gone since 1932, but since 1987 electric rail passenger trains have been operating between downtown Sacramento and Swanston, partially over the former SN right-of-way. This Watt I-80 train has discharged its passengers at Swanston. (Paul C. Trimble photograph.)

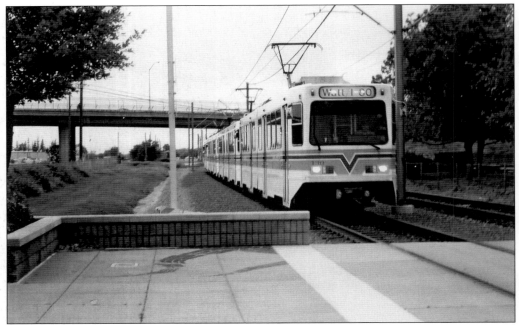

Arriving at Swanston Station, Sacramento RT Metro has just left the old SN right-of-way. A Model U-2 from Siemens-Düwag in Germany, No. 130, in the lead, is faster and carries more passengers than did the old streetcars from the St. Louis Car Company. (Paul C. Trimble photograph.)

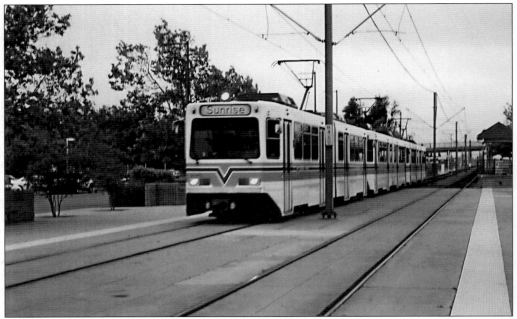

In from Watt I-80, a three-unit train of Sacramento's RT Metro, headed by No. 135, arrives at Swanston. Next, the train will roll over the former SN right-of-way while en route to downtown Sacramento and Sunrise Station. Whether BART, Sacramento RT Metro, Sacramento River Train, or Western Railway Museum, the Sacramento Northern lives! (Paul C. Trimble photograph.)